NFTs

An Illustrated
FIELD GUIDE

BY ALYSSA PLACE

ILLUSTRATED BY REBECCA PRY

13-Digit ISBN: 978-1-95151-163-0
10-Digit ISBN: 1-95151-163-8

This book may be ordered by mail from the publisher. Please include $5.99 for postage and handling. Please support your local bookseller first!

Books published by Cider Mill Press Book Publishers are available at special discounts for bulk purchases in the United States by corporations, institutions, and other organizations. For more information, please contact the publisher.

Cider Mill Press Book Publishers
"Where good books are ready for press"
501 Nelson Place
Nashville, Tennessee 37214

cidermillpress.com

Cover and interior design by Melissa Gerber
Typography: Adobe Caslon, Caslon 540, DIN 2014,
Eveleth Clean Thin, Fontbox Boathouse Filled

Printed in China

23 24 25 26 27 DSC 5 4 3 2 1

First Edition

NFTS ARE A JUGGERNAUT
THAT CANNOT BE STOPPED.

—*Steve Aoki*

THE NFTS THAT EVERYONE'S TALKING
ABOUT...MOST PEOPLE DON'T
KNOW WHAT IT IS, INCLUDING ME,
BUT THAT'S NOT GOING TO STOP ME
FROM EXPLAINING IT TO YOU.

—*Ellen DeGeneres*

CONTENTS

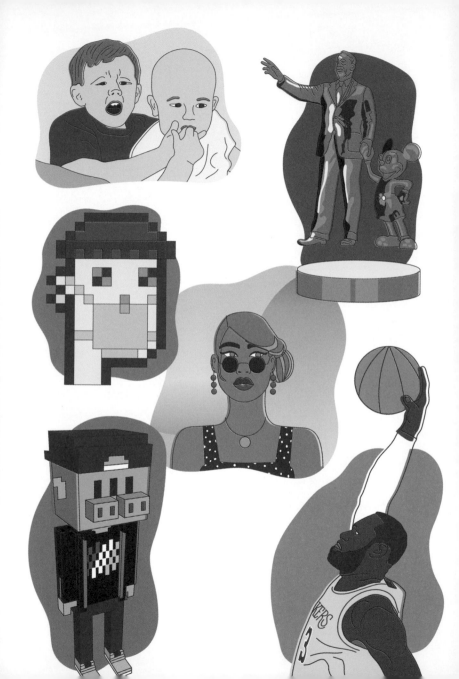

INTRODUCTION

If words like "crypto," "Bitcoin," "non-fungible tokens," and "metaverse" sound more like "huh?" "what?" "blerg," and "no thanks," you've probably picked up the right book.

ULTRAVIOLET

It's gotten increasingly hard to turn a blind eye to the complex world of cryptocurrencies and non-fungible tokens that has taken the internet by storm—celebrities like Reese Witherspoon, Ellen DeGeneres, Snoop Dogg, Steph Curry, Jimmy Fallon, and more all collect and promote this hi-tech way of investing in the digital world. While you may not have the wallet of Jimmy or Ellen, you can have a little knowledge.

NFTs—or non-fungible tokens—are digital assets traded using cryptocurrency, a virtual form of money that's not controlled by a centralized entity like a government or a bank. It's like the Wild West out there! But think of an NFT like a CVS receipt: somewhere on that three-foot-long piece of paper filled with numbers, codes and coupons is data revealing that you own something. In basic terms, that's what an NFT is: a certificate of ownership for stuff that exists on the World Wide Web. It says that you—and you alone—have the proof that you own whatever it is you purchased. And when you own an NFT, you own the original version of that thing, that exists nowhere else. Pretty exclusive stuff!

NFTs are completely unique and come in many shapes and forms. Throughout this book, you'll find a variety of internet mementos and digital collectibles: William Shatner's tooth X-ray; a rock album by aughts-era heartthrobs Kings of Leon, portraits, GIFs, paintings, a bored-looking ape, a pudgy penguin, movie scripts, and a song about Amelia Earhart's distress calls. Are you still with me?

Like other valuable commodities that are unique and cannot be duplicated (think, diamonds! beachfront property!), NFTs are selling for a high price—in some cases, millions of dollars! In 2021 alone, sales of NFTs ballooned to $18.5 billion. However, extreme volatility

saw the value of the market drop 25 percent in the first few months of 2022, signaling that these assets aren't for the faint of heart (or those who are attached to their cash).

Despite that, celebrities, artists, musicians, athletes, and more continue to flock to NFTs. For some, it's a way to flaunt their wealth. For others, it's an opportunity to set their own price for what they think their stuff is worth, without the old guard stepping in. For many, it's just an opportunity to look cool and avoid FOMO. Whatever the reason, NFTs are here to stay—as more of our lives exist online, there's more for us to explore. This field guide will help you break down the complexities of this type of investing and become well-versed in the digital art world. If that all fails, you'll at least win a trivia question about the most expensive NFT sold to date. (Answer: Merge, for $91.8 million.)

Ready to dive in? First, a word of warning!

YOUR WORD OF WARNING

A disclaimer on what this book is not: this is not financial advice. This is not an invitation to spend your birthday money on an NFT, on the off chance you will be able to resell it for $10 million. This book does not contain a hidden message that encourages you to quit your job, scribble on your iPad, and try to sell it for $10 million. Listen, no one reading this book is making $10 million at any given time, now, or in the future. We clear?

Cryptocurrencies and NFTs are a volatile investment strategy. Like any investment decision, these assets should be researched, explored, and potentially purchased at your own financial risk.

FREQUENTLY USED TERMS AND LINGO

A few more things before we get to the fun stuff (like mutant zombie apes). Like any good digital spelunker setting off on your journey for knowledge, you need to know the lingo. Here are a few words and phrases that will pop up throughout this book:

ALGORITHM: A set of step-by-step procedures or rules that complete a task. Many NFTs are created using an algorithm, which duplicates basic similarities with variations and modifications.

BITCOIN: A digital currency that can be bought, sold, and exchanged without going through an intermediary, like a bank. Created in 2009, Bitcoin was the original form of cryptocurrency.

BLOCKCHAIN: A digital database that keeps track of cryptocurrency transactions. The records are secure and are difficult to copy or hack, creating an unchangeable record of transactions and data.

CRYPTOCURRENCY: A virtual currency that acts as money but is not controlled by a person, group, or entity, like the government or a bank.

DECENTRALIZING: Transferring the decision-making away from individuals or corporations to a dispersed network. This can eliminate bias and ensure decisions aren't being made by one individual or group, around things like cost or value.

EXCHANGE: An online trading platform where users can buy and sell cryptocurrencies or exchange crypto for other digital assets or cash.

FUNGIBLE: An asset that can be duplicated, copied, and traded interchangeably, like cash or stocks.

MARKETPLACE: Digital technology that allows buyers and sellers of cryptocurrencies, NFTs, and other currencies to deal directly with each other instead of working through an intermediary, like a bank.

METAVERSE: An immersive virtual world where individuals can build a digital life, interact, and make social connections online.

NFT: Short for non-fungible token. NFTs are assets that have a unique code and metadata associated with them, so they cannot be traded or duplicated.

NIFTY GATEWAY: A digital online auction platform that sells NFT art. The platform was founded in 2018 by twin brothers Duncan and Griffin Cock Foster, who later sold it to another set of twin brothers, Cameron and Tyler Winklevoss, in 2019.

NON-FUNGIBLE: An asset that is unique and cannot be duplicated or copied. The uniqueness of the item can add or subtract value. For example, diamonds, baseball cards, land, and, of course, digital tokens are non-fungible.

OPENSEA: The first digital marketplace created for NFTs and other exclusive digital collectibles. The platform was created in 2017 by Devin Finzer and Alex Atallah.

WALLET: A place to store your digital assets, like cryptocurrency and NFTs.

This handy field guide will help put all of these terms into context, walk you through the basics, and reveal some colorful facts and history around the most popular and pricey NFTs on the market today. Let's dive in!

ANIMAL NFTS

LIONS AND APES AND PENGUINS?! OH MY!

BORED APE YACHT CLUB #8817

ARTIST	PRICE
Yuga Labs	$3.4 million

DATE SOLD: October 27, 2021

SELLER OR PLATFORM: Sotheby's

THE TAKEAWAY: Stupefied status symbols for the stupidly rich and famous.

WHAT AM I *ACTUALLY* LOOKING AT? Bored Ape Yacht Club #8817 is one of ten thousand unique cartoons in this popular NFT collection. While all of the characters sport dazed and confused expressions, BAYC #8817 has that extra lil' something that helps him stand out from the crowd: golden fur. It is not seen in nature, or on his other ape friends, as just 1 percent of the BAYC characters have this glittering veneer. BAYC #8817 has something else differentiating it too—an insane price tag. He's the most expensive BAYC ever sold (yet). And he's ready to celebrate (ironically, of course): the ape has a '90s-era spinner hat and a noisemaker ready to blow. Hey, guess what? You're not invited to his party.

If it seems like the world of NFTs is a zoo gone wild, the Bored Ape Yacht Club is king of the jungle. Celebrities like Jimmy Fallon, Madonna, Justin Bieber, and Steph Curry all own BAYC NFTs, and with an average price tag of $200,000, entry to the club is not cheap. But once you're in, you're in: owners get to exit the virtual world for an IRL one, with exclusive parties and meetups for BAYC owners. People who own these NFTs also get commercial usage rights, meaning we may get to watch a BAYC movie in the future. Lucky us!

WHAT MAKES IT SPECIAL? BAYC #8817 has gold fur, and a golden price tag—so far, he's the most expensive NFT sold in the BAYC universe. Collectively, the BAYC has pulled in over a billion dollars in sales since it began creating in 2021. And with movies and a metaverse in production, there's no stopping these placid primates—if they can summon enough enthusiasm, that is.

THE ONLINE BUZZ:

"AuctionUpdate #BAYC #8817 sells for a RECORD $3,408,000 USD! This is the first time it has been made available since it was minted. Less than 1% of all Bored Apes have the gold fur trait."

—*Tweet by Sotheby's Metaverse, October 27, 2021*

COOL CAT #1490

ARTISTS	PRICE
Tom Williamson, Rob Mehew, Evan Luza, and Colin Egan	$1.1 million

DATE SOLD: October 4, 2021

SELLER OR PLATFORM: Doxia Studio

THE TAKEAWAY: A special edition zombie cat—you'd better be zonked if you're spending that much on a computer file.

WHAT AM I *ACTUALLY* LOOKING AT? Cool Cat #1490 is one of three thousand unique Cool Cats NFTs. The image kicked off 2021's first-ever Halloween NFT sale, where artists and sellers anticipated that creepy, spooky, and downright bizarre NFTs would grow in popularity. Because NFT collectors want to be grade A originals, that's exactly what happened. Cool Cat #1490 features a cat with an exposed brain, blood, scratches, and tears to its cat clothes. The design was custom-made, one of only nine in the entire Cool Cats collection. This made it more valuable, and it sold for $1.1 million, the first Cool Cats NFT to clear the million-dollar mark. You can buy *a lot* of fun-size candy bars with that loot. The seller is going to use the money to open an animal shelter. Cue the aws! (Or meows!)

Cool Cats launched in July 2021, backed by a four-person creative team of a blockchain expert, web developer and engineer, creative director, and—wait for it—catoonist, the illustrator of the characters. Since launching, the cats have raked in over $300 million and have a menagerie of fans, including pro boxer (and known ear biter) Mike Tyson. Reese Witherspoon has also dipped her toe into the kitty litter with a purchase of a Cool Cats NFT.

WHAT MAKES IT SPECIAL? Cool Cat #1490 is one of nine original illustrated characters in the Cool Cats club. While all Cool Cats have defining characteristics that make them unique, this is the only Zombie Cat in the collection. Owners get access to exclusive games, community events, and more. Who said cats are antisocial?

THE ONLINE BUZZ:

"SPOOKY SALE ALERT zombie cat just sold for 320 ETH! congratulations to @DoxiaStudio (the minter of this 1/1) who plans to use the funds to start their own animal shelter. we like the cats, and we love this community."

—*Tweet by @coolcatsnft, official Twitter account for Cool Cats, October 4, 2021*

"LET'S GOOOOOO! I have just made the first $1,000,000 @coolcatsnft purchase! The @coolcatsnft team and community are all amazing and I couldn't be more honored to own this 1/1 Zombie cat. Shoutout to @DoxiaStudio for the deal and good luck with your Animal Shelter! LET'S GOOOO!"

—*Tweet by @Bornadoesntcare, the buyer of the NFT, October 5, 2021*

LAZY LION #2698

ARTIST	PRICE
rizzio.eth	$80,475.85

DATE SOLD: June 16, 2022

SELLER OR PLATFORM: OpenSea

THE TAKEAWAY: If you want to be king of the jungle, you'd better have the funds.

WHAT AM I *ACTUALLY* LOOKING AT? If you're getting the sense that all of these NFTs seem to be eerily similar to each other, you may not be surprised that Lazy Lions share many of the same traits as their friends in the NFT jungle. Like the Bored Ape Yacht Club, the ten thousand Lazy Lions boast multicolored manes and not-seen-in-nature props like cigarettes, baseball caps, and, in one case, a bow and arrow. (Lions need a backup plan too.) Many also feature glazed, lazy expressions, like they've just finished off the leg of a zebra (or perhaps swallowed up your life savings). And like those affable apes, Lazy Lions are now a status symbol in the NFT universe. While they haven't yet topped the BAYC in price, they've established themselves near

the top of the food chain—when the collection was released, all ten thousand sold out in less than five hours.

Once collectors have their hands (ahem, paws) on one of these collectible cats, they are initiated into the clubhouse. Lazy Lions live on a private island (not biologically accurate), in bungalows (also…not accurate) that collectors can furnish with their other NFT art collections. The community of cubs is referred to as kings and queens who are ready to rock and *roar*!

WHAT MAKES IT SPECIAL? Lazy Lion #2698 may not be the most expensive NFT on the list, but he might have the most swagger. This lion features some rare traits, like a pink body, a lion's head earring, and a crown, which only 1 percent of the ten thousand Lazy Lions NFTs boast. This lion sold for close to a cool $100,000. Maybe his saliva-soaked tongue is out because he's thinking about all of the organic prey he can get his paws on now?

THE ONLINE BUZZ:
"Joined the Pride @LazyLionsNFT."

—*Tweet by @Nigel_NFT, June 6, 2022*

"I don't know much about NFTs, but my first purchase ever was today and it's a @LazyLionsNFT. I hope the community welcomes me with open arms. #ROAR #LazyLionsNFT #LazyLions #LionsfollowLions."

—*Tweet by @0xSavag3, June 6, 2022*

MUTANT APE YACHT CLUB #4849

ARTIST	PRICE
Yuga Labs	$1.13 million

DATE SOLD: August 29, 2021

SELLER OR PLATFORM: OpenSea

THE TAKEAWAY: There's more of these things???

WHAT AM I *ACTUALLY* LOOKING AT? The Mutant Ape Yacht Club (MAYC) is a spinoff of the wildly popular (and expensive) OGs of the NFT world. After the success of the Bored Ape Yacht Club, those pixels repopulated after the creators handed out "Mutant Serum." To create a feeding frenzy at the zoo, ten thousand virtual vials went to owners of original Bored Ape Yacht Club designs. One drop of this magical potion (made from the egomania distilled from the collectors who own them, I think) transformed the apes into mutant versions, featuring melted skin, green teeth, glowing eyes, astronaut helmets, and body piercings, among other charming characteristics. It's like when your younger sibling decides to go goth for the annual Christmas card.

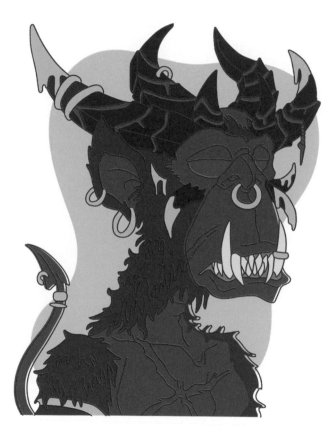

Another common feature that matches their more sophisticated older brothers: the price. Mutant Ape Yacht Club #4849 sold for more than $1 million in 2021—in 2022, its resale auction value had mutated to about $30 million! When the entire twenty-thousand-piece collection was originally put on the NFT marketplace, collectors spent nearly $96 million to snatch it up. That's a lot of chumps buying chimps.

WHAT MAKES IT SPECIAL? MAYC #4849, known as the Mega Demon, features horns, gold textural details like a nose hoop, and glowing, steaming eyes. Like the BAYC, the more unique the features, the higher the price. It was the most expensive MAYC NFT sold in the original drop, and has since inflated in value. And what exactly does this demon do? Exist as a status symbol for the superrich, just like its predecessors before it…and whatever they mutate into in the virtual world hereafter.

THE ONLINE BUZZ:
"F— it. Mutants Saturday."

—*Tweet by @BoredApeYC announcing the release of the new collection, August 24, 2021*

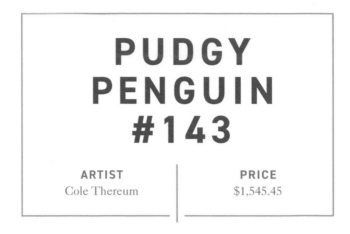

PUDGY PENGUIN #143

ARTIST	PRICE
Cole Thereum	$1,545.45

DATE SOLD: June 15, 2022

SELLER OR PLATFORM: OpenSea

THE TAKEAWAY: Cute…and kind of cutthroat?!

WHAT AM I *ACTUALLY* LOOKING AT? The Pudgy Penguins collection consists of 8,888 unique characters, created by an algorithm that gives them individual traits like clothing, accessories, and facial expressions. Like the BAYC and MAYC, Pudgy Penguins see themselves as a community existing on the NFT iceberg, calling themselves The Huddle, with warm welcomes for new members of the flock. The entire collection sold out within twenty minutes and then wasted no time in mating to create Lil Pudgys, a collection of twenty-two thousand pieces. Original owners of the Pudgy Penguins NFTs had dibs on expanding their colony first, before the remaining fledglings were sent out of the nest into the big wide world of the NFT marketplace.

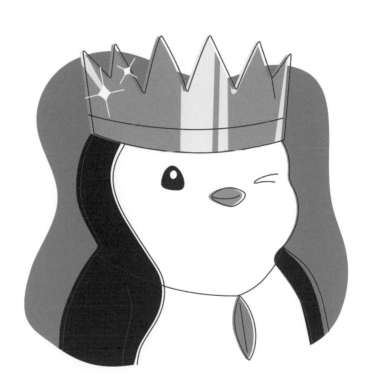

But not all is bliss in penguin land. In January 2022, the group's original mother hen (oop, wrong species) was ousted by the community. The Pudgy Penguins universe claimed the owner engaged in poor leadership and accused him of taking bribes and purposefully tanking the price of the NFT. The entire collection was resold to entrepreneur Lucas Getz for $2.5 million in April 2022, and he quickly saw a return on investment. In the first twenty-four hours after the sale, almost $2.45 million in Pudgy Penguins were traded, and the collection has continued to spike in value. The new exec has plans for an Antarctic-themed gaming metaverse, children's books, and more. Seems like the Pudgy Penguins crew has happy feet once again.

WHAT MAKES IT SPECIAL? Pudgy Penguin #143 might just be the king of the iceberg: the crown on top of his pudgy lil head is one of the rarest traits in the nearly nine-thousand-piece collection. While he sold for just $1,545.45, mere ice cubes in NFT trading, new leadership of the community could signal some big returns in the future.

THE ONLINE BUZZ:

"The blizzard has passed, and the snow is settling. The Huddle has shown its resilience. It's time to waddle to the promised land. We're ready to announce the worst kept secret in Web3. Our next chapter has begun: new team, new roadmap, new heights."

—*Tweet by @pudgypenguins announcing their new ownership, April 3, 2022*

"I AM MY PENGUIN AND MY PENGUIN IS ME."

—*Tweet by @JoeyMooose, April 1, 2022*

CELEBRITY NFTS

CELEBS DISCOVER A WHOLE NEW OUTLET TO
SHOW HOW RICH AND OUT OF TOUCH THEY ARE.

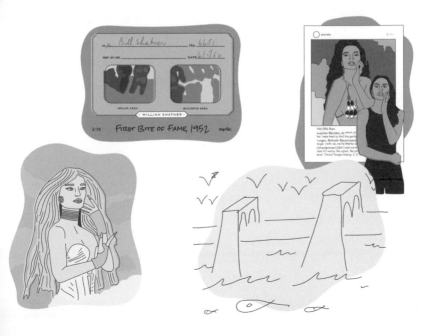

Bill Shatner No. 6651
REF. BY OR: DATE 6/1/52
MOLAR AREA BICUSPID AREA
• WILLIAM SHATNER •
3/10 FIRST BITE OF FAME, 1952

emote
146,006 likes

JOHN CLEESE'S BROOKLYN BRIDGE NFT

ARTIST	PRICE
John Cleese	$36,671

DATE SOLD: April 2, 2021

SELLER OR PLATFORM: OpenSea

THE TAKEAWAY: A commentary on the ridiculousness of the superrich, that's made this already-rich guy even richer.

WHAT AM I *ACTUALLY* LOOKING AT? Fine art or iPad scribbles? In the dizzying world of NFTs, the lines get blurry. That's not stopping sellers and buyers from jumping on the bandwagon, or in this case, off the bridge. Comedy icon John Cleese, known for Monty Python fame, staged perhaps the biggest coup of his comedy career, listing an iPad sketch of the Brooklyn Bridge for $69.34 million, around the same price as the second-most-expensive NFT ever sold, Beeple's Everydays: The First 5000 Days. But maybe the joke's not really on him. While Cleese didn't get $69 million, he got more than $36,000 for the sketch. Not a bad payoff for some Sunday-night scribbles.

Cleese said he was making a comment on the out-of-control nature of the NFT market, listing his NFT for the same price as other high-profile sales. But whether he's poking fun at the trends or padding his wallet, the frenzy surrounding what buyers consider to be one-of-a-kind art shows that the art world has changed forever.

WHAT MAKES IT SPECIAL? This joke seems to have escaped the people John Cleese was aiming his comedic claws at. While Cleese said the drawing was a social commentary on the money-hungry NFT art world, his fans missed the punch line, or didn't care, snatching up the piece for nearly $40,000. Cleese is laughing all the way to the bank.

THE ONLINE BUZZ:

"Today, I've got a bridge to sell you. The Brooklyn Bridge."

—*Video posted on John Cleese's Twitter, March 19, 2021*

"Hello! It is time you meet my alter ego 'Unnamed Artist.' I'm delighted to offer you the opportunity of a lifetime. I'm selling my 1st NFT. Though bidding starts at 100.00, you can 'BUY IT NOW' for 69,346,250.50!"

—*Tweet by John Cleese, March 19, 2021*

ELLEN DEGENERES'S WOMAN WITH STICK CAT

ARTIST	PRICE
Ellen DeGeneres	$33,495

DATE SOLD: April 26, 2021

SELLER OR PLATFORM: Bitski

THE TAKEAWAY: The former queen of nice becomes a queen of crypto.

WHAT AM I *ACTUALLY* LOOKING AT? Ellen DeGeneres is known for being many things: a comedian, a talk-show host, an animated fish, a not-so-nice boss…erm, where were we? Oh right, the former host's many hats now include "NFT artist." DeGeneres sold a stick drawing of her cat, along with a monologue of her explaining what an NFT is on her show, on the NFT marketplace, banking nearly $33,495. In a good PR move, she donated the cash to World Central Kitchen, which provides millions of meals to people in need around the world.

The NFT collection consisted of three offerings: a platinum package, which sold for $14,555 and included an NFT of her onstage monologue; ten available gold packages, which

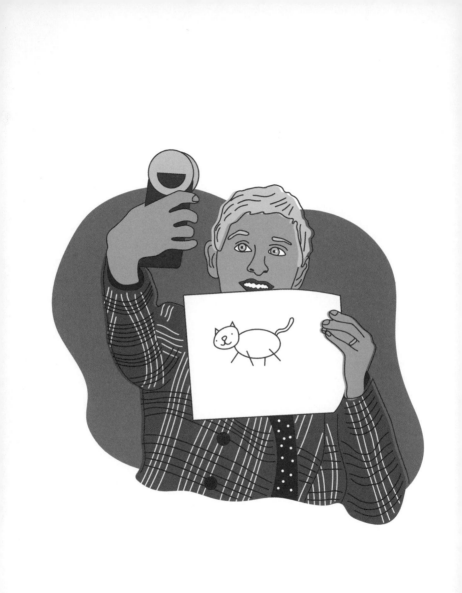

featured a picture of Ellen taking a picture, holding the drawing of her cat (meta! Those went for $2,500 a pop—and wait! A few are still available, while supplies last!); and a silver package, a close-up selfie of the top of her head, showing Ellen holding the cat drawing in front of her face. Those NFTs could be snagged for one hundred dollars, and the entire collection sold out. Looks like Ellen's dancing her way to the bank!

WHAT MAKES IT SPECIAL? DeGeneres joined a growing population of celebrities getting involved in the NFT fracas. NFTs are about attention, and celebrities love attention! It's a match made in narcissistic heaven. At least she's using her fame for charity. But with an end to her show and a slightly tarnished reputation, who knows when DeGeneres will be grooving back into the hearts and wallets of crypto collectors. Maybe Kelly Clarkson will take over the baton? Daytime crypto wars! This fall on NBC!

THE ONLINE BUZZ:

"I like to stay current, and if you count on me to stay current, good for you. That's a shame at the same time. The NFTs that everyone is talking about…I'm not talking about the National Federation of Training Bras…. Most people don't know what it is, including me, but that's not going to stop me from explaining it to you."

—*Ellen DeGeneres in her NFT monologue, April 13, 2021*

PARIS HILTON'S ICONIC CRYPTO QUEEN

ARTISTS	PRICE
Paris Hilton and Blake Kathryn	$1.1 million

DATE SOLD: April 17, 2021

SELLER OR PLATFORM: Nifty Gateway

THE TAKEAWAY: An OG influencer heads to the metaverse.

WHAT AM I *ACTUALLY* LOOKING AT? Pop culture pariah Paris Hilton may act like a dumb blonde, but she just might be far from it when it comes to her investing acumen. Hilton has involved herself in cryptocurrencies like Bitcoin since 2016, and has been dabbling in NFTs, releasing several collections since 2020. The self-dubbed "OG Crypto Queen" (can't fault her confidence!) released her first NFT back in 2020, a drawing of her cat, aptly called Kitty. The NFT even won an award for Best Charity NFT, after it was sold for $17,000. Celebs—saving the world, one non-fungible token at a time.

Hilton's next foray was an NFT collection with digital artist Blake Kathryn, which launched in April 2020. Iconic Crypto Queen features a Barbie-fied Hilton, her luscious locks blowing in the digital breeze, donning diamond-encrusted gloves

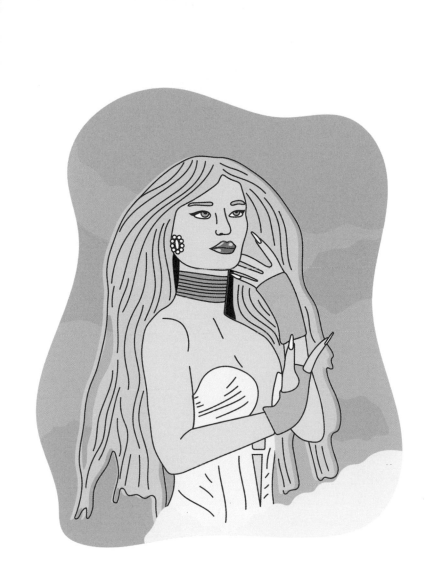

and a bejeweled choker. The full collection, titled Planet Paris, also features NFTs of her dog Tinkerbell and a pastel-painted metaverse. If you want a peek inside Paris's mind, she's more than ready to brag about it. Celebrities get attention for dumb s—. As Hilton has famously said: "That's hot!"

WHAT MAKES IT SPECIAL? Paris Hilton is far from the first celebrity to get involved in the metaverse, and she won't be the last. And her interest in the virtual art world has her not just selling her own wares, but collecting them too. Hilton says she has more than 150 NFTs in her personal collection. For someone who reshaped the concept of fame in the early aughts, maybe she'll do the same for NFTs? Since NFTs are probably one of the most complicated things, um, *ever*, this is quite the step up from her star turn on *The Simple Life*!

THE ONLINE BUZZ:

"Paris Hilton's drop crushing it. 24hr auction 1/1 NFT is now up over $1 million. That's hot."

—*Tweet by Tyler Winklevoss, April 17, 2021*

"In the early 2000s, when I started turning my personal brand into a multibillion-dollar business, innovating, empowering others and pushing the boundaries of how I interact with my fans have been passions of mine. As a #bossbabe, I've been so lucky to pursue all three and being in the NFT space allows me to combine all my creative passions. It's like the ultimate dream…. I plan to go big with NFTs, innovating, investing, and collecting. My first drop is coming soon. I can't wait."

—*Paris Hilton on her website, April 8, 2021*

EMILY RATAJKOWSKI'S BUYING MYSELF BACK: A MODEL FOR REDISTRIBUTION

ARTIST	PRICE
Emily Ratajkowski	$175,000

DATE SOLD: May 13, 2021

SELLER OR PLATFORM: Christie's

THE TAKEAWAY: A model selling a photo of herself, modeling in front of a photo of herself, modeling.

WHAT AM I *ACTUALLY* LOOKING AT? Model and writer Emily Ratajkowski's Buying Myself Back: A Model for Redistribution began with a photo shoot. The model posed for *Sports Illustrated* magazine and then posted the photo on her Instagram, as models (and influencers…and Kardashian sisters) are wont to do. But in a bit of modern-day art heist, artist Richard Prince snatched a few of her Instagram posts off her feed, including the *Sports Illustrated* snap, blew them up, and hung them on a wall, charging tens of thousands of dollars through a New York City gallery. The model didn't see a dime, and instead had to spend a pile of her own: Ratajkowski purchased her Instagram

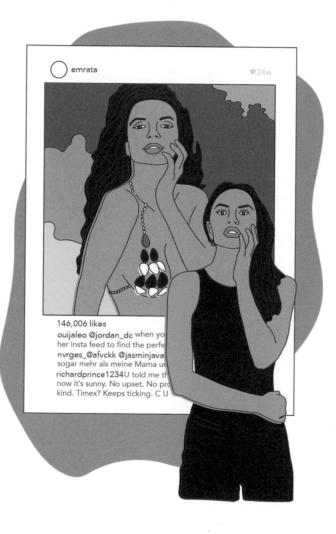

photo back for $81,000, hung the canvas up, took a photo of herself in front of it, posted it on Instagram…wait. Will this ever end?!

In her case, yes—with $175,000 in her pocket and the rights to her NFT in her hands. Each time the NFT is sold going forward, Ratajkowski will get a cut of the profits. Does this mean your random photo of avocado toast may soon be worth millions? You probably shouldn't get your hopes up.

WHAT MAKES IT SPECIAL? NFT as social commentary? Ratajkowski wrote that her NFT allowed her to take back control of her image, and profit from it herself. Giving creators, artists, models, and musicians more power over their content is setting a precedent, one that's sure to make the rich and famous…even richer and famous(er).

THE ONLINE BUZZ:

"In a step toward my ongoing effort to reclaim and control my image, I'm thrilled to announce my first conceptual artwork to ever come to market, an NFT entitled Buying Myself Back: A Model for Redistribution."

"Using the newly introduced medium of NFTs, I hope to symbolically set a precedent for women and ownership online, one that allows for women to have ongoing authority over their image and to receive rightful compensation for its usage and distribution."

—*Tweets by Emily Ratajkowski, April 23, 2021*

WILLIAM SHATNER'S TOOTH X-RAY

ARTIST
William Shatner

PRICE
$6,800

DATE SOLD: July 30, 2020

SELLER OR PLATFORM: shatnercards.io

THE TAKEAWAY: Chew on this: a seventy-year-old tooth X-ray becomes a digital collectible item worth thousands.

WHAT AM I *ACTUALLY* LOOKING AT? Yep, it's exactly what it says it is—an X-ray of William Shatner's tooth. The pop culture icon, famous for his role in *Star Trek* (for which he won Emmys) and his money-grabbing stint as the Priceline Negotiator guy (for which he won…nothing), decided to package up pieces of his illustrious career as NFT trading cards. Each pack of cards featured between five and thirty digital pieces of memorabilia from his storied career, including candid photos from the set of *Star Trek*, and even images of Shatner first meeting his daughter. Most emotional, of course, is that picture of his tooth, the first such item to ever be made into an NFT. Yes, he's laughing at us this time.

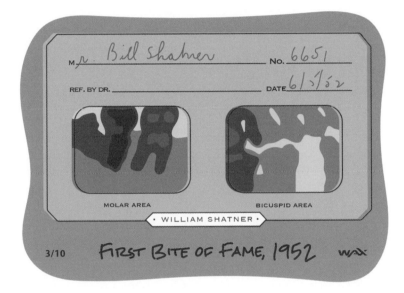

M**r.** Bill Shatner No. 6651

REF. BY DR. _____ DATE 6/5/52

MOLAR AREA BICUSPID AREA

· WILLIAM SHATNER ·

3/10 FIRST BITE OF FAME, 1952 WAX

Shatner posted ten thousand packs of digital trading cards on the NFT marketplace, and the entire collection sold out in less than ten minutes. That's faster than a space mission, or even a single episode of his latest sitcom, with its made-up working title: I'm Old Now and Want to Make Money Off My Career—Sue Me! Live on CBS, starting this March!

WHAT MAKES IT SPECIAL? Shatner has had a long career, and the brands and shows he's famous for have certainly made a lot of money off him—why not keep some of it for himself? Trading cards have come a long way since the actor's heyday, though—these NFT packs sold for $25 apiece and have exploded in value to be worth around $7,000. That's probably enough for Shatner to pay off his long-overdue Delta Dental bill.

THE ONLINE BUZZ:

"Yes. You want a pack of my NFT trading cards? I put X-ray images of my tooth from 1953 up as an NFT. Who does something like that? Me!"

—*Tweet by William Shatner, February 20, 2021*

"I have these dental records, and the joke is, this is something I can get my teeth into. It's just an X-ray of a tooth. But it's my tooth!"

—*William Shatner interview with* Cointelegraph Magazine, *June 24, 2020*

CHARACTER NFTS

PIXELS, PUNKS, AND FLOWERPOTS
JOIN THE NFT FRACAS.

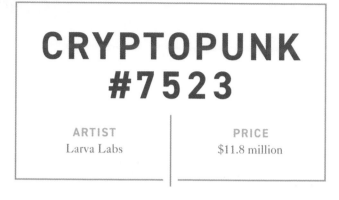

CRYPTOPUNK #7523

ARTIST	PRICE
Larva Labs	$11.8 million

DATE SOLD: June 10, 2021

SELLER OR PLATFORM: Sotheby's

THE TAKEAWAY: It's a pre-COVID, mask-wearing alien that looks like your AIM avatar from 1998.

WHAT AM I *ACTUALLY* LOOKING AT? If aliens are going to take over Earth eventually, they're getting a head start in the world of NFTs. CryptoPunks are some of the oldest NFTs on the Ethereum blockchain—where people can create, sell, and store NFTs. In 2017, two Canadian-based web developers launched a pixelated character generator, churning out ten thousand CryptoPunks. The characters were posted for free, where they were immediately snatched up before being resold. The frenzy made CryptoPunks crypto gold, with the average character selling for a minimum of $150,000, though prices vary widely depending on their uniqueness. Each punk comes with an accessory and a unique characteristic, like a mohawk, beanie hat, cigarette, or earring. Picture Iggy Pop, but pixelated.

If the punk-rock aesthetic is all about sticking it to the man, these NFTs are making a few of them insanely rich. CryptoPunk #7523, a 24-by-24-pixel alien character wearing a face mask, sold for nearly $12 million in 2021, through the auction house Sotheby's. High art meets low resolution.

WHAT MAKES IT SPECIAL? Did this pile of pixels predict the future? While it was created in 2017, #7523 sports a medical-grade mask, foretelling the COVID-era fashion that's been ubiquitous since 2020. But while you can buy a ten-pack of KN95s for $5, this mask is a tad more expensive—like, $11.8 million more. When it was sold, it was the second-most-expensive NFT on the market. But the mask isn't the only thing that makes this punk precious: the alien character is one of just nine featured in the ten-thousand-strong CryptoPunks collection. Rock on, pricey punks!

THE ONLINE BUZZ:

"Moments ago in our #London saleroom, an extremely rare 'Alien' CryptoPunk #7523 from the collection of @sillytuna sold for $11.8M as part of our #NativelyDigital NFT auction—setting a new world auction record for a single CryptoPunk."

—*Tweet by Sotheby's, June 10, 2021*

FLOWER GIRL #424

ARTIST	PRICE
Varvara Alay	$2,200

DATE SOLD: February 3, 2022

SELLER OR PLATFORM: OpenSea

THE TAKEAWAY: A superhero buys a super girl.

WHAT AM I *ACTUALLY* LOOKING AT? The Flower Girls NFT collection is a woman-led community blossoming on the online cryptocurrency marketplace. Created by artist and illustrator Varvara Alay, The Flower Girls are ten thousand randomly generated characters, compiled from nearly one thousand hand-drawn elements and characteristics. The images have a Renaissance art–style portraiture that brings old-world art right into the future—and into the hands of some very famous folks. Reese Witherspoon, Eva Longoria, Gwyneth Paltrow, and Brie Larson all own The Flower Girls NFTs, raising the profiles of these botanical beauties.

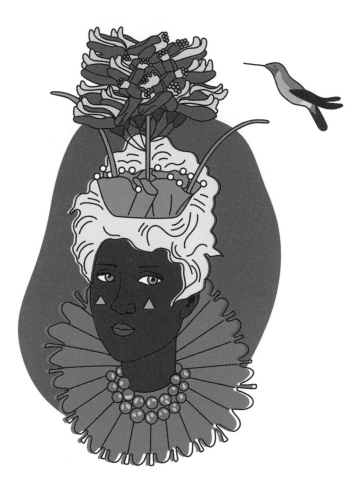

The Flower Girls community works hard to cultivate a beautiful garden of like-minded collectors: members are not allowed to be anonymous, and the community gives 20 percent of each sale to charity. The founder has also pledged an additional 5 percent to be earmarked toward supporting other woman-created NFT art. In 2022, The Flower Girls signed with a major entertainment production company, Dolphin Entertainment. Coming soon: The Flower Girls movies, shows, and other media! A blossoming meadow of opportunity—and money—awaits!

WHAT MAKES IT SPECIAL? Flower Girl #424 was purchased by Brie Larson, Oscar winner and Marvel Universe heroine. This NFT features some unique and intricate features: a two-string pearl-beaded necklace, which less than 1 percent of The Flower Girls have, along with a veritable bouquet of blue-and-cream flowers on her head. Flower Girl #452's serene stare is unaffected by the hummingbird buzzing in her ear—perhaps it's a threatened patriarchy, reacting to the increasing presence of women in the NFT space? Girls, let your garden grow!

THE ONLINE BUZZ:
"#NewProfilePic—got a @FlowerGirlsNFT by @VarvaraAlay."
—*Tweet by Brie Larson, February 4, 2022*

MEEBIT #17522

ARTIST	PRICE
Larva Labs	$2.1 million

DATE SOLD: July 9, 2021

SELLER OR PLATFORM: OpenSea

THE TAKEAWAY: Should have saved those Lego sets from third grade.

WHAT AM I *ACTUALLY* LOOKING AT? Meebits are a collection of twenty thousand 3D avatars, created from an algorithm that gives them unique characteristics. If this formula sounds familiar, it might be because Larva Labs, which also created CryptoPunks, designed these block-headed bums. This is the lab's third NFT collection, and the team turned to voxels, or pixels with volume, to build the characters. The 3D quality brought these characters to life and inspired some robust sales: in the first eight hours on the market, 9,000 Meebits were sold, for a total of $75 million, with the other eleven thousand given as a gift to owners of CryptoPunks NFTs. Beginner's luck!

Meebits can attribute some of their success to their predecessors, but they've since taken on a life of their own. When you buy a Meebit, you're also buying an art project: owners get access to a 3D model that can be animated to perform stunts, or they can print out their NFT, IRL, with a 3DP (IYKYK). If that's too real, users can also turn their 3D art back into a 2D picture, perfect for flaunting on social media as a profile pic. At the end of the day, if you don't use your NFT as a Twitter profile photo, what's the point of buying it at all?

WHAT MAKES IT SPECIAL? Meebit #17522 is the most expensive Meebit ever sold, with the owner paying a record-smashing $2.1 million for this pile of 3D pixels. Like other NFTs with over-the-top price tags, #17522 has some rare traits that set it apart. This pixelated piggy features a backward hat, leather jacket, and neon sneakers. Could this pig be a punk?! As Meebits could be considered the younger brothers of CryptoPunks, the more similarities, the better. But there's only so much room for NFT domination: in March 2022, Yuga Labs, the creators of Bored Ape Yacht Club, announced their intention to purchase the intellectual property rights of both CryptoPunks and Meebits. Think there's enough room at the zoo for everyone?

THE ONLINE BUZZ:

"Meebit #17522 just sold for 1000 ETH ($2,113,280 USD)."

—*Tweet by @nftnow, July 10, 2021*

"The future has legs. #meebits."

—*Tweet by @MeebitsNFTs, March 3, 2022*

WOW #9248

ARTIST
Yam Karkai

PRICE
$615,900

DATE SOLD: January 24, 2022

SELLER OR PLATFORM: OpenSea

THE TAKEAWAY: "Who run the world (of NFTs)? *Girls!*"
—A revision to a Beyoncé classic.

WHAT AM I *ACTUALLY* LOOKING AT? Who says NFTs
need to be a boy's club? Apparently…most of the creators of
NFTs. While 95 percent of NFT artists and creators are men,
women are interested in art, tech, and spending boatloads of
money too! To close the gap, digital artist and illustrator Yam
Karkai jumped into the space with World of Women, also known
as WoW. The ten-thousand-piece collection features randomly
generated female characters who sport unique traits like tattoos,
jewelry, and flashy makeup looks.

These NFTs have caught the eye of power players in
Hollywood: Reese Witherspoon, Shonda Rhimes, and Eva
Longoria all have their own World of Women characters, and
Witherspoon brokered a partnership with the creators in 2022,
opening future opportunities for feature films.and TV. If you're
not Reese Witherspoon, there are benefits for you too: owners

get access to an educational hub so they can become smarter and savvier crypto investors. What's the equivalent of a glass ceiling in the virtual world? Seems like Karkai is ready to break it.

WHAT MAKES IT SPECIAL? WoW #9248 is the most expensive character sold in the collection so far, fetching more than half a million dollars. In 2022 alone, the collection made more than $40 million in sales over the course of just two weeks. Like other randomly generated NFTs, the more unique the characteristics, the higher the price. WoW #9248 sports green hair and a gold medallion necklace, called a WoW coin. Think the owner can trade that in for, I don't know, something women *really* want, like paid maternity leave, equal pay, universal childcare, and access to abortion services? I guess a WoW coin is fine though.

THE ONLINE BUZZ:

"While the crypto and NFT space is largely dominated by men, there are inspiring leaders like World of Women creating incredible communities for women during this massive shift for media and technology."

—*Statement by Reese Witherspoon on her partnership with World of Women, February 2022*

"We love welcoming people into the NFT space and creating a supportive environment for everyone—from new community members and collectors to emerging artists and NFT enthusiasts."

—*World of Women website welcome statement*

ZOMBIE ZOO #255: ZOMBIE GIRL WITH A PEARL EARRING

ARTISTS
Zombie Zoo Keeper
and Emi Kusano

PRICE
$1,981

DATE SOLD: April 2, 2022

SELLER OR PLATFORM: OpenSea

THE TAKEAWAY: Kids these days! Yeah, this eight-year-old boy is smarter than you.

WHAT AM I *ACTUALLY* LOOKING AT? Zombie Zoo is a 200-piece NFT collection designed by anonymous artist Zombie Zoo Keeper, with the help of his mom. Yes, his *mom*, because Zombie Zoo Keeper is a preteen making an absolute killing on NFTs that he started creating when he was eight. Think back: What were you doing when you were eight? It doesn't matter, because it probably wasn't making you and your parents millionaires.

Zombie Zoo Keeper's mom saw her son whiling away his childhood drawing Minecraft-style pixel art on his iPad and,

looking for a mom-of-the-year award, challenged him to find a buyer for his collection. You gotta pay your way around here, little child! But the collection was a success and has since drawn the attention of high-profile celebs and NFT collectors like Steve Aoki. The collection is even inspiring an anime series, set to go into production in 2022. Today, the prolific young artist says he produces at least three pictures per day, noting that he can make up to seven on days when elementary school isn't taking up too much of his time.

WHAT MAKES IT SPECIAL? Zombie Zoo Keeper is proof that the NFT art market isn't just for finance bros and crypto bros, but for little boy bros too. Anyone can be an artist, and anything can be an NFT! Zombie Zoo #255 is digging a little deeper into his presumably limited art history background with a pixelated interpretation of Johannes Vermeer's classic portrait, *Girl with the Pearl Earring*. While that version is hanging in The Hague and is worth tens of millions of dollars, Zombie Zoo Keeper's version should probably just be hanging on his mom's fridge. Instead, it sold for nearly $2,000 on the OpenSea marketplace.

THE ONLINE BUZZ:

"Until my work is really famous on the internet, I won't tell my friends or teachers about it."

—*Interview with Zombie Zoo Keeper on cryptocurrency website CoinCu, September 11, 2021*

MEME NFTS

YOUR FAVORITE AUGHTS-ERA MEMES GET A GLOW UP.

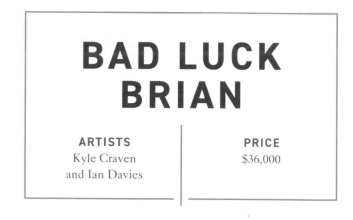

BAD LUCK BRIAN

ARTISTS
Kyle Craven
and Ian Davies

PRICE
$36,000

DATE SOLD: March 11, 2021

SELLER OR PLATFORM: Foundation

THE TAKEAWAY: Bad luck turns into big bucks.

WHAT AM I *ACTUALLY* LOOKING AT? When memes from 2012 are now considered memorabilia, I think we're all officially old. Bad Luck Brian populated every Tumblr page and Facebook feed in the 2010s, capturing the malaise of middle school, paired with semi-ironic captions highlighting an Alanis Morissette level of life's inconveniences. The original meme was captioned, "Takes driving test…gets first DUI." The internet then did its internet-y thing, spinning the captions into even more embarrassing, awkward, and unfortunate scenarios.

Craven's awkward middle school moment has led to a lifetime of opportunities, including an endorsement deal with McDonald's. "Gets endorsement deal…has to eat Filet-O-Fish." And nearly a decade after that original photo was posted,

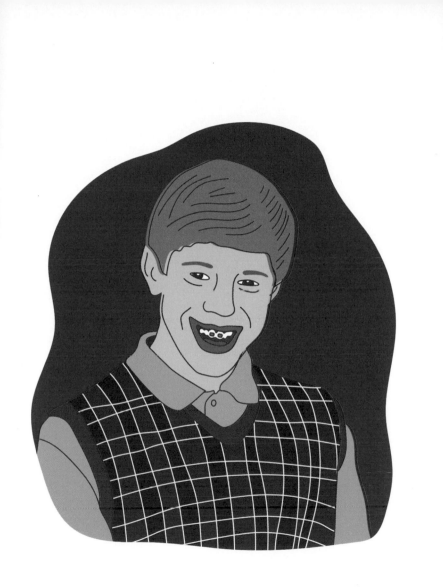

Bad Luck Brian is a full-grown man with bills to pay! He sold the original photo as an NFT for $36,000, joining many other aughts-era memes in the latest frontier of digital media. What's in store for Brian next? "Sells NFT…crypto tanks in value immediately." Predictions, predictions.

WHAT MAKES IT SPECIAL? The 2012 meme started as a joke among pals. Craven's friend Ian Davies posted the photo on Reddit, and the rest has become internet history. Because there's no shortage of bad luck in the world, the meme has resonated among internet users looking for a laugh at some random guy's expense! Turning it into an NFT gives it a second life, along with some extra income: while the former awkward teen now owns his own construction company, Craven will get a cut of the profits each time the NFT's owner licenses the pic. Wonder if Bob the Yearbook Photographer will get a cut too?

THE ONLINE BUZZ:
"It's definitely life-changing, but [it doesn't define my life]. I live a pretty normal life outside the fact that my face is all over the internet."

—*Kyle Craven interview with KnowYourMeme.com, February 14, 2020*

CHARLIE BIT MY FINGER

ARTIST	PRICE
Howard Davies-Carr	$760,999

DATE SOLD: May 23, 2021

SELLER AND PLATFORM: Origin Protocol

THE TAKEAWAY: Making nearly a million dollars off a YouTube video doesn't hurt.

WHAT AM I *ACTUALLY* LOOKING AT? "Charlie Bit My Finger" is the most viral and most viewed YouTube video of all time—and now it will live on as an NFT to make money for this little English family *foreverrrrr*. The original video was taken by Howard Davies-Carr, the father of two bouncing, biting babes, and was sent to the immediate family for a good chuckle. The adorable British brothers, Charlie and Harry, are seen sitting together when Charlie gives his older brother's finger a little bite, and history is made! Since that fateful day in 2007, the video has been viewed more than 900 million times on YouTube and has spurred countless parodies, memes, and video remixes. It also kicked off a phase of viral video hysteria that we have yet to recover from.

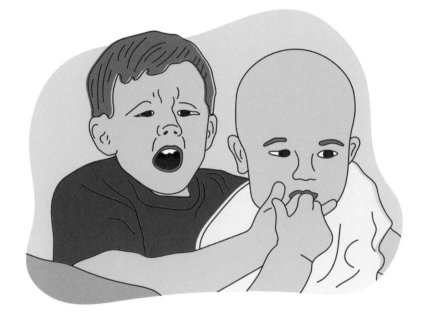

When the video was presented as an NFT, the plan was to have it taken down from YouTube, but the new owner had second thoughts and kept it posted. He still gets the exclusive rights to the clip—and for more than $760,000, that seems kind of worth it. Charlie and Harry were probably a bit too young to do the math *then*, but that shakes out to be $13,571.42 per second of finger snacking. The family said the proceeds will go toward that less-than-glamorous money-grubbing scheme: college.

WHAT MAKES IT SPECIAL? "Charlie Bit My Finger" remains the highest-viewed internet video of all time. The guy dropped three quarters of a million dollars, so he's gotta get something, right? Yep! Along with the video clip, he got the opportunity to film a parody version of the original clip with the now-teenage brothers. Wonder if Charlie prefers toes now?

THE ONLINE BUZZ:

"I was just watching TV and just decided to bite him. He put his finger in my mouth, so I just bit."

—*Interview with Charlie Davies-Carr on British talk show* This Morning, *June 4, 2017*

"The buyer felt that the video is an important part of popular culture and shouldn't be taken down. It will now live on YouTube for the masses to continue enjoying as well as memorialized as an NFT on the blockchain."

—*Statement to NPR from Howard Davies-Carr after the sale of the NFT, May 30, 2021*

DISASTER GIRL

ARTIST
Dave Roth

PRICE
$500,000

DATE SOLD: April 17, 2021

SELLER OR PLATFORM: Foundation

THE TAKEAWAY: Dealing with disasters by turning them into internet jokes since 2007.

WHAT AM I *ACTUALLY* LOOKING AT? If it feels like the world is on fire and you're helpless to stop it, maybe turn that frown upside down and channel the energy of a four-year-old smirking as a house burns to the ground. The infamous meme of preschooler Zoë Roth's dead-eyed grin has made its way around the internet for nearly two decades—inspiring countless other disaster memes since. Disasters, but act like you don't care! Seems like the perfect attitude for today's world: the Earth is literally on fire, the world as we know it has changed forever, and we're still just Instagramming our way through it. Just like Zoë would do.

The Roths turned fire into fortune with their sale—an NFT of the original meme sold for nearly half a million dollars. They get to keep the copyright and 10 percent of future sales. That

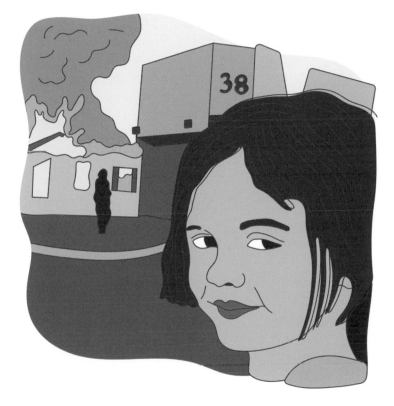

money will come in handy, as even the OG Disaster Girl isn't immune to the travesty of student loan debt. Roth planned to use some of the funds to pay off her college education, and donate some change to charity too.

WHAT MAKES IT SPECIAL? Who decides what makes a meme? Probably not the person in it. Turning a meme into an NFT helps the original artist regain control of their image and make some money off it too. Disaster Girl is one of several memes being turned into NFTs, and Zoë even consulted another meme magnet, Bad Luck Brian, for advice before selling the digital pic. If his advice was "take the money and run," message received!

THE ONLINE BUZZ:

"Once it's out there, it's out there and there's nothing you can do about it. It always finds a way to stay relevant with whatever new kind of awful, terrible, bad thing is happening, so I've laughed at a lot of them."

—*Dave Roth interview with* The New York Times, *April 29, 2021*

"It's the only thing that memes can do to take control."

—*Zoë Roth interview with* The New York Times, *April 29, 2021*

DOGE

ARTIST
Atsuko Sato

PRICE
$4 million

DATE SOLD: June 11, 2021

SELLER OR PLATFORM: Zora

THE TAKEAWAY: Woof! This dog is richer than you will ever be.

WHAT AM I *ACTUALLY* LOOKING AT? Doge is one of the most iconic memes of the internet age—and now it's one of the most expensive NFTs ever sold. The image of a Shiba Inu judging you harshly sold for an insane $4 million as an NFT. But even before then, the dynamic dog had flooded many an internet feed, inspiring a rabid online community and even its own currency, Dogecoin, which can be used as a cryptocurrency to buy more stuff on the blockchain.

But the conniving canine has much humbler roots—the dog's owner snapped a few pics for her personal blog back in 2010, and those basic WordPress skills took off in meme form. Users would paste Comic Sans text onto the image of the pup, revealing the dog's inner Karen persona. Phrases like "Keep ur hands away from me," and "so scare" showed that the dog had yet to complete elementary school English…and had a lot of judgy

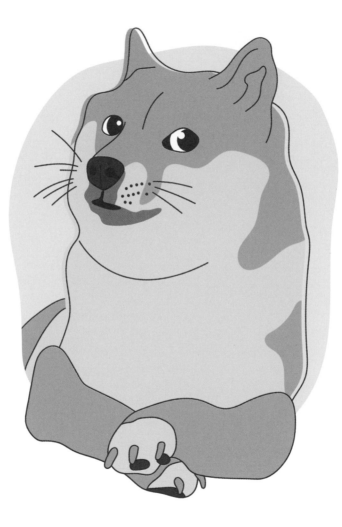

commentary on her mind. Seems like after this sale, the only thing this dog's owner, a kindergarten teacher, should be saying is, "I so rich."

WHAT MAKES IT SPECIAL? The Doge NFT clocks in as the most expensive meme turned NFT ever sold, and the potential resale is expected to head straight toward the cryptocurrency stratosphere. After the NFT was purchased, the new owner decided to break the NFT apart into individual pieces, which he plans to sell as $DOG tokens. Nearly seventeen million tokens will be made, potentially banking the new owner $220 million in sales. This dog better be wearing a diamond-encrusted collar!

THE ONLINE BUZZ:

"With great pawer comes great respawnsibility. If you are reading this, you are special, much special. We are beyond excited to have you on board as we set out to begin a journey that will echo in eternity. Here is how to get started and become an internet culture pioneer."

—*Blog post by the buyer of Doge, PleasrDAO, August 31, 2021*

NYAN CAT

ARTIST
Chris Torres

PRICE
$587,000

DATE SOLD: February 19, 2021

SELLER OR PLATFORM: Foundation

THE TAKEAWAY: It's like if Pop-Tarts came out with a "solid gold" special edition flavor.

WHAT AM I *ACTUALLY* LOOKING AT? Nyan Cat, originally called PopTart Cat by creator Chris Torres, is an animated flying cat with a Pop-Tarts body. The animation was posted as a GIF in 2011 and quickly went viral. Nothing says "inexplicable internet fame" like a cat…with a Pop-Tarts body… flying through the air…in 2011. Just embrace the weird! The GIF was originally inspired by Torres's actual cat, Marty, who passed away and crossed the rainbow bridge to pet heaven. He's now looking down on his owner's good fortune—the NFT sparked a bidding war that drove up the price to nearly $600,000! That's *a lot* of nutritionally lacking breakfast pastries!

The original GIF became known as Nyan Cat after another YouTube user paired the GIF with the musical stylings of a

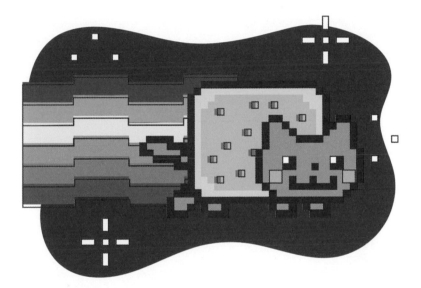

Japanese song, "Nyanyanyanyanyanyanya!" Five months after this golden pairing, the video was viewed nearly forty million times, and reached nearly two hundred million views by 2022. The owner of the NFT gets sole bragging rights that he—and he alone—owns the original version of the GIF. Fortunately, it's still available online and wherever Pop-Tarts are sold to bring you joy and rainbows.

WHAT MAKES IT SPECIAL? Nyan Cat is one of many memes turned NFTs that are selling like hotcakes (or…Pop-Tarts?). In most cases, the memes and viral videos remain on the internet for all to enjoy—the owners just get the expensive privilege of saying, "It's mine now!" Think of it like a pricey receipt…like a more than half-a-million-dollar one. Nyan Cat was sold on Foundation, a platform that has made its name selling internet memes. Seems like there's a lot of money in aught-era internet nostalgia!

THE ONLINE BUZZ:

"I feel like I've opened the floodgates."

—*Chris Torres interview with* The New York Times, *February 19, 2021*

MODERN ART NFTS

THESE NFTS MIGHT HAVE PICASSO
ROLLING OVER IN HIS GRAVE.

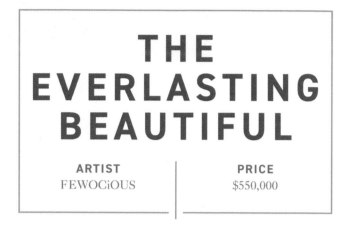

THE EVERLASTING BEAUTIFUL

ARTIST
FEWOCiOUS

PRICE
$550,000

DATE SOLD: March 6, 2021

SELLER OR PLATFORM: Nifty Gateway

THE TAKEAWAY: If you're not making half a million dollars before graduating from high school, are you even Gen Z?

WHAT AM I *ACTUALLY* LOOKING AT? Victor Langlois, who goes by the name FEWOCiOUS, is a young digital artist who's made a splash in the NFT space for their emotional and passionate art pieces, depicting their childhood struggles and search for identity. Langlois, who identifies as queer and transgender, turned to art as an outlet away from an abusive and traumatic childhood. Needing to keep their drawings secret from their conservative grandparents, they used a digital tablet to create their art, posting the pieces online and finding support through virtual communities for transgender youths. When FEWOCiOUS turned eighteen, they packed up and moved to Seattle, selling prints and stickers on Twitter to pay the bills.

Langlois started selling their paintings as NFTs, and the world (and the famous auction house Christie's) was quick to notice. The EverLasting Beautiful, which depicts their struggle with identity, sold for more than half a million dollars after the nineteen-year-old became the youngest artist to ever be represented by the art connoisseurs. FEWOCiOUS has since made more than $26 million from NFTs. (Quite a step up from those $5 stickers.) Today, they're using their fame and fortune to support up-and-coming transgender artists. If this whole thing makes you feel old and unaccomplished, it should.

WHAT MAKES IT SPECIAL? The EverLasting Beautiful is a Picasso-inspired, graffiti-style image of a face with different styles of eyes, arms, hair, and ears, representing Langlois's challenges with identity. The piece sold for $550,000, and the owner walked away with both a digital NFT and the canvas of the original painting. The EverLasting Beautiful was an NFT launchpad for Langlois's stratospheric success—their art has resonated with the queer community. Langlois has no plans to slow down. Since selling The EverLasting Beautiful, they've produced an entire collection for Christie's, titled Hello, i'm Victor (FEWOCiOUS) and This Is My Life. The collection sold out so quickly, the website crashed. #OKboomer.

THE ONLINE BUZZ:

"I pour my heart to art."

—*Tweet by FEWOCiOUS, September 10, 2021*

EVERYDAYS: THE FIRST 5000 DAYS

ARTIST
Mike Winkelmann,
a.k.a. Beeple

PRICE
$69.3 million

DATE SOLD: March 11, 2021

SELLER OR PLATFORM: Christie's

THE TAKEAWAY: Imagine if your high school–era sketchbook were excavated from under your bed and sold for $69 million.

WHAT AM I *ACTUALLY* LOOKING AT? Everydays: The First 5000 Days is a digital collage of images created by the artist Mike Winkelmann, known online as Beeple, every day for more than a decade. Beeple compiled the images in order. They depict a variety of themes tracing the trajectory of his style and tone. From hand-drawn images of political cartoons and riffs on popular advertisements to drawings of celebrities and public figures like Elvis and Tom Hanks, Beeple had thousands of opportunities to express himself through his doodles. His later work lambastes political figures like former president Trump and former senator Hillary Clinton, and he's even drawn a decapitated Buzz Lightyear. "God, Mom, get out of my room!"

This was Beeple's third foray into the world of NFTs, and give him credit for his persistence: Everydays sold for $69 million, setting a record for Christie's. The auction house turned his web journal into "fine art," and he's now established himself as one of the richest living artists.

WHAT MAKES IT SPECIAL? This NFT is the second-most-expensive digital artwork ever sold, and it catapulted Beeple into the digital art stratosphere. The scramble to own something new and unique drove the price of this NFT through the roof and made Beeple an unofficial expert on NFTs. He's worked with Katy Perry, appeared on Jimmy Fallon's show, and made tens of millions of dollars more on his subsequent NFT drops. Not bad for a self-taught artist. Could it be your time to see how much those refrigerator drawings might now be worth?

THE ONLINE BUZZ:

"The piece they're auctioning is an NFT minted by @makersplaceco of the first 5000 days of everydays...one massive image covering May 1st 2007—January 7, 2021. I could not be more honored and humbled to be representing the digital art community for this historic sale!!! <3"

—*Tweet by Beeple, February 16, 2021*

"Breaking News: The first NFT sold by Christie's was just bought for $69.3 million. The price for 'Everydays—The First 5000 Days,' by the artist Beeple, is a new high for an artwork that exists only digitally."

—*Tweet by* The New York Times, *March 11, 2021*

THE
FUNGIBLE

ARTIST
Pak

PRICE
$16.8 million

DATE SOLD: April 14, 2021

SELLER OR PLATFORM: Sotheby's

THE TAKEAWAY: Tetris, but make it fine art.

WHAT AM I *ACTUALLY* LOOKING AT? Digital artist
Pak likes to play with shapes—in this NFT collection, users
purchased either individual cubes, or combined them into sets
of five to a thousand. Each cube cost $500. Depending on the
number of cubes a user purchased, their NFT would expand in
size and shape. The sale lasted three days, ending in a fever pitch
over the unknown number of cubes that remained. By the end of
the auction, buyers were spending $1,500 per cube, triple what
they had been worth just seventy-two hours before. Pak said The
Fungible was a commentary on "what is value?" Or maybe what
he really meant was, "How much can I get these dummies to
spend?" If you're a third-day buyer, it might be time to take part
in some reflection...perhaps your cube can reveal the answer?

Sotheby's represented Pak for its first NFT auction ever on the site, and in the span of three days, more than twenty-three thousand cubes had been sold, totalling nearly $17 million. Looks like Lego missed a major opportunity.

WHAT MAKES IT SPECIAL? The Fungible was just the start for Pak, who took the success of this collection and created something similar months later with Merge. Instead of blocks, Merge used spheres, which resonated with corner-averse buyers and became one of the most expensive NFTs of all time. Perhaps his next foray will explore the controversial…pyramid?!

THE ONLINE BUZZ:
"The Fungible NFTs are minting. I would like to thank the @niftygateway team for their extreme technical efforts, to @Sothebys team (specially, @MaxMoore_Art) for taking the leap of faith for this big change, and to all collectors for taking on this journey with us. Now we begin."

—*Tweet by Pak, April 15, 2021*

HASHMASKS: SEX

ARTIST	PRICE
Suum Cuique Labs	$650,000

DATE SOLD: February 2, 2021

SELLER OR PLATFORM: OpenSea

THE TAKEAWAY: Would a Hashmask with any other name be as valuable?

WHAT AM I *ACTUALLY* LOOKING AT? Hashmasks are an NFT collection made up of 16,384 digital portraits, created by seventy artists from around the world. Each piece features tribal motifs like masks and hieroglyphic-inspired backgrounds, along with unique traits and objects for each character. An algorithm then combined these traits to create each portrait. While there are many details to each Hashmask, one important thing is missing: their names. In this case, that's a good thing, since each buyer gets control over the name, adding to its originality and rarity. No two portraits can share a name, and the name can change if and when it's resold.

The collection's blend of hand-drawn and digital art elements makes it unique among algorithm-generated NFTs

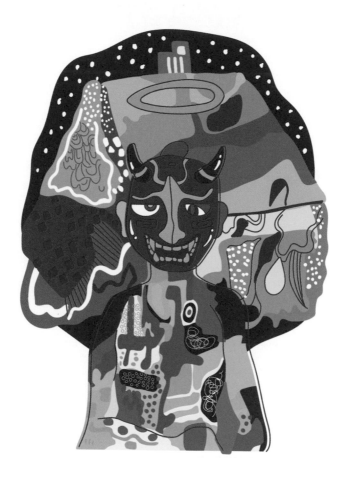

like the Bored Ape Yacht Club and CryptoPunks. The frenzy for something totally original comes with a hefty price tag: in the first week after the collection was released, all 16,384 characters were purchased for a collective $16 million. Since then, their value has skyrocketed, with some increasing one hundred thousand times in value. Probably no untitled Hashmasks NFTs in this bunch!

WHAT MAKES IT SPECIAL? The "creatively" named Sex Hashmark NFT was purchased in February 2021 and became the community's most expensive NFT to date. The demonic digital artwork sold for $650,000 and features some of the rarest characteristics in the collection: a golden halo, which only 0.12 percent of the portraits have, along with devil horns and a collage-style, hand-painted background. The owner, known by his given name of Danny, said he was interested in purchasing "ultra-high-end NFTs." For that price, seems like mission accomplished.

THE ONLINE BUZZ:

"I've decided to one-up myself and purchased this mystical halo demon 420 $ETH! @TheHashmasks #NFTs."

—*Tweet by buyer Seedphrase, February 2, 2021*

"We are the artists of artists."

—*Interview with "David," the founder of Hashmask, with* Decrypt *magazine, February 18, 2021*

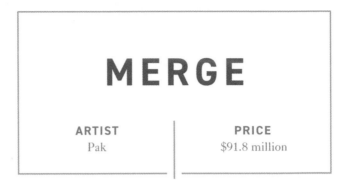

MERGE

ARTIST
Pak

PRICE
$91.8 million

DATE SOLD: December 4, 2021

SELLER OR PLATFORM: Nifty Gateway

THE TAKEAWAY: More plus more just equals more.

WHAT AM I *ACTUALLY* LOOKING AT? Merge is a collection of mass tokens—the units that make up NFTs. The tokens merge to form a spherical shape, which changes in size depending on the number of tokens a person purchases. The more tokens, the larger the mass. But wait, there's more! Collectors were also incentivized to buy more tokens with the promise of a bonus added after the sale was completed. The more tokens you buy, the bigger the bonus. It's like Chuck E. Cheese, for rich people!

But those incentives were just the thing overenthusiastic, insanely wealthy NFT collectors needed to score a piece of the pie…erm, sphere. While some people may think that spending millions of coins on tokens seems a little strange, almost thirty thousand people would happen to disagree. When the sale was

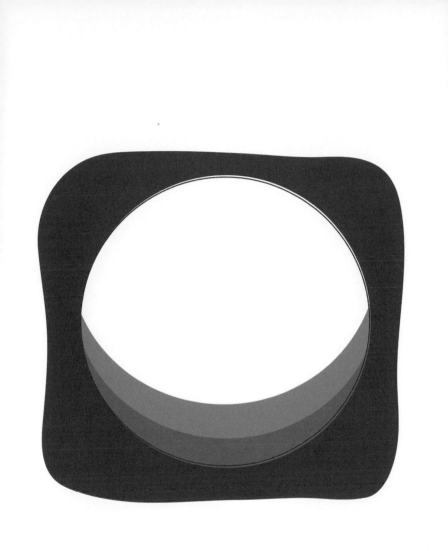

announced in December 2021, NFT insiders who already had ownership of a Pak NFT had first dibs on Merge, paying $299 per token. The rest of these eager investors had to shell out $400 apiece. And time was of the essence when it came to filling their coffers: prices increased $25 every six hours, capping off at $575. All in all, 28,984 buyers snapped up 312,686 tokens, for a total sale of nearly $92 million!

WHAT MAKES IT SPECIAL? Merge broke several records in the NFT world: it's one of the only NFTs to be bought by a group, and it made its anonymous creator one of the wealthiest artists alive today. Investors also had full faith in the artist. They purchased units without actually seeing what the final NFT would look like. Blind faith, or blind stupidity? With the resale value high and Pak, a highly sought-after NFT artist, these investors see something most of us don't.

THE ONLINE BUZZ:

"Merge is a single artwork distributed across many tokens, not a collection of artworks. Because without the whole, the tokens that make this artwork don't convey a narrative. They're pointless pebbles."

—*Tweet by Pak, December 7, 2021*

"A single book can be many pages. A single mosaic can be many pebbles. So, a single digital artwork can be many tokens."

—*Tweet by Pak, December 7, 2021*

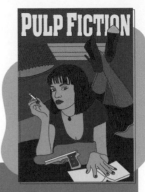

MOVIE NFTS

DRAMA! INTRIGUE! NFTS HIT THE SILVER SCREEN.

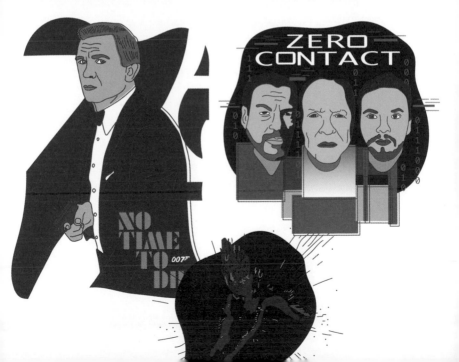

DISNEY GOLDEN MOMENTS: PARTNERS STATUE

ARTIST
Walt Disney
Animation Studios

PRICE
$333

DATE SOLD: November 12, 2021

SELLER OR PLATFORM: VeVe

THE TAKEAWAY: The happiest place in the metaverse.

WHAT AM I *ACTUALLY* LOOKING AT? Disney Golden Moments is a set of eleven NFTs created by Walt Disney Animation Studios, depicting iconic moments and characters within the Disney franchise. The most iconic and rarest of the bunch is the Walt and Mickey statue, which exists IRL at the entrance of Cinderella's Castle at Florida's Disney World theme park. But while the park is open to anyone willing to pay an exorbitant entry fee, slap on some mouse ears, and sell their soul to Sleeping Beauty, these NFTs are available to just a select few: less than five thousand Disney Golden Moments statues were made for the NFT drop, creating a Tower of Terror of pandemonium to snatch one up.

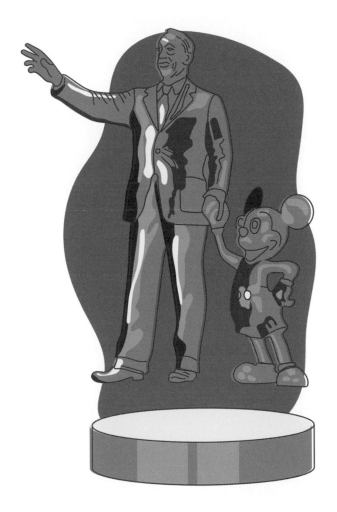

Joining Walt and his pal in the full Disney Golden Moments collection are other well-known Disney characters, like *Frozen*'s Elsa, *Toy Story*'s Pizza Planet truck, the Avengers logo, and *Star Wars'* R2-D2. Yeah, we get it—Disney has influenced almost every pop culture reference of the past thirty years, and now they're going for our NFTs too?! Leave some for the rest of us, Walt! Originally, the prices were in the range of the standard admission fee to the parks, but now, the NFTs are reselling at a high value, solidifying the value of the Disney brand, even virtually. Wonder what those Imagineers will think up next!

WHAT MAKES IT SPECIAL? Disney has established its icon status across movies and TV, and has created theme parks, merchandise, and teen heartthrobs (we love you, Ryan Gosling!). The list goes on and on. And the Disney machine has figured out that no matter your age or income, people want in. The same is true for their NFT drop—the 4,333 Walt and Mickey statues are the only ones that will ever be made, meaning huge demand in the resale market. For those lucky buyers, there's an added bonus: a three-month trial to Disney+! Seems like an incredibly involved scheme for getting more people to cancel their Netflix accounts.

THE ONLINE BUZZ:

"I only hope that we never lose sight of one thing, that it was all started by a mouse."

—*Walt Disney on TV, October 27, 1954*

JAMES BOND
NO TIME TO DIE
TRIUMPH SCRAMBLER

ARTISTS	PRICE
MGM Studios and EON Productions	$87

DATE SOLD: February 20, 2022

SELLER OR PLATFORM: VeVe

THE TAKEAWAY: NFT…James NFT.

WHAT AM I *ACTUALLY* LOOKING AT? There's nothing more classic than James Bond. So why not merge an iconic piece of cinema with a passing internet trend? That's the bet MGM and EON Productions, which has owned the rights to the James Bond films since 1952, decided to take when they released a collection of NFTs to coincide with the release of the most recent action-packed caper, *No Time to Die*. The collection includes an NFT version of the Triumph Scrambler 1200 motorcycle, featured in many a chase scene, along with a digital NFT movie stub, masks, and other virtual memorabilia from the film. Can't they just send Daniel Craig right to our door? People would shell out major cash for that!

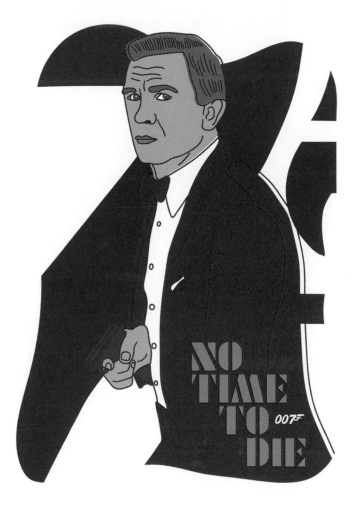

No Time to Die struggled with COVID-era delays in filming, and the NFT release seemed like a new way to ramp up interest and excitement around a movie that has already been released twenty-five times over its seven-decade history. "If it ain't broke, don't fix it" is the typical studio message. But it seems to have worked for James Bond. The film ended up bringing in $774.2 million, and the studio continued to release limited edition NFTs throughout 2022.

WHAT MAKES IT SPECIAL? VeVe is banking on the power of movie memorabilia to fuel its business. The platform has already hosted auctions for the Disney Golden Moments NFTs, along with a suite of other cinematic stuff in the digital realm. James Bond may be out of everyone's league, but the NFT prices weren't. That Triumph Scrambler goes for $14,000 IRL; as an NFT, buyers could ride high for just $87. They got a 3D replica of the bike, along with audio files from the film. Living vicariously through iconic on-screen personas: priceless.

THE ONLINE BUZZ:

"As one of the longest running and most successful film franchises of all time, James Bond continues to evolve and innovate to meet the demands of our devoted audiences around the globe. We are thrilled to partner with VeVe to create the first-ever digital collectible from *No Time to Die*, and offer fans an exclusive opportunity to own a piece of cinematic history."

—*Statement from Stephen Bruno, Chief Marketing Officer at MGM, September 22, 2021*

SPIDER-MAN: NO WAY HOME

ARTISTS	PRICE
Sony Pictures and Cub Studios	$16,971

DATE SOLD: December 28, 2021

SELLER OR PLATFORM: WAX

THE TAKEAWAY: AMC is basically paying you to come to the movies.

WHAT AM I *ACTUALLY* LOOKING AT? AMC *really* wants you to get off your worn-out couch and come back to their movie theaters. The struggling cinema chain teamed up with Sony ahead of the highly anticipated 2021 release of *Spider-Man: No Way Home,* with a collection of nearly ninety thousand NFTs. People who purchased advance tickets to the film and were part of their membership club, AMC Stubs, were given exclusive access to their very own NFT. Users had a month to redeem a special code, and they'd be sent one of one hundred uniquely designed NFTs to add to their crypto wallets. The thing most people aren't really adding to their actual wallets anymore? Movie tickets.

However, the marketing scheme paid off: nearly all ninety thousand NFTs sold out, and the movie became the top-grossing film of 2021, banking $1.05 billion at the box office. While the NFTs are reselling for around $30, one particular piece resold for close to $17,000, pointing yet again to the instability of the NFT marketplace. While this was a win for AMC, fans weren't that impressed. Twitter had a field day with the rudimentary animations, posting memes and Reddit threads roasting the theater chain's efforts at being tech savvy. AMC laughed back… all the way to the bank.

WHAT MAKES IT SPECIAL? As movie theaters struggle to remain relevant in an increasingly digital world, more studios are finding innovative ways to get consumers to want the stuff that comes with movies: ticket stubs, movie memorabilia, and the like, just digitally. AMC has more NFT plans up its sleeve—after releasing nearly ninety thousand NFTs related to the *Spider-Man* film, that boost in ticket sales could make a movie-NFT pairing just as common as movies and popcorn once were. And once they figure out how to bottle that buttered popcorn smell, they'll really be in business!

THE ONLINE BUZZ:

"I am told that one of those NFTs was just re-sold for $16,900! At least one person is smiling today."

—*Tweet by Adam Aron, CEO of AMC Theaters, December 28, 2021*

"I cannot wait to burden the environment with this new Spider-Man NFT I just scored."

—*Tweet by @MasterTainment, December 22, 2021*

PULP FICTION ROYALE WITH CHEESE

ARTISTS	**PRICE**
Quentin Tarantino and SCRT Labs	$1.1 million

DATE SOLD: January 24, 2022

SELLER OR PLATFORM: Tarantino NFTs

THE TAKEAWAY: A lot of cheddar for a scene about cheese.

WHAT AM I *ACTUALLY* LOOKING AT? No one loves Quentin Tarantino more than Quentin Tarantino, and he's taking that self-congratulatory love to a new level the way all rich and famous Hollywood types do, by releasing his own collection of NFTs. Tarantino handwrote the script to his 1994 cult classic, *Pulp Fiction,* and he's looking to get reimbursed for all those legal pads and pens by selling off seven digital copies of iconic scenes from the film. Each NFT also comes with personalized audio commentary explaining the background of the scene and its significance. Think twenty-four-hour DVD bonus content—except it's just a few minutes and costs millions of dollars.

The first scene Tarantino released as an NFT, Royale with Cheese, is a conversation between the movie's hit men, John

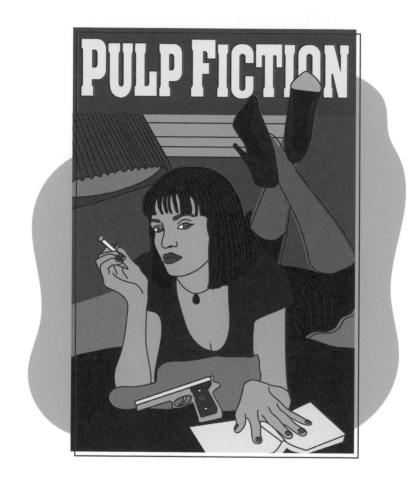

Travolta as Vincent and Samuel L. Jackson as Jules, discussing the differences between the European and United States approach to drugs, women, and…cheeseburgers. Brilliant! Because it's in a Tarantino film, this conversation is replete with stringy hair, pithy, nonsensical dialogue, and plenty of subtext. You can either buy the NFT to find out more about his *process*, or just head to Reddit for the deep dive that rabid fans have been doing for the past two decades.

WHAT MAKES IT SPECIAL? The *Pulp Fiction* NFTs have already seen their fair share of controversy: Miramax, the studio that released the film, has sued Tarantino multiple times over ownership claims. Tarantino says he owns the paper script and the copyright, and that he is benefiting off his pricey little stack of paper. Miramax, however, has countered that *it* owns the rights to the film and everything associated with it. When someone makes money, it had better be them! Despite the legal challenge, Tarantino moved forward, selling the NFT of the first scene for over a million dollars. Since then, the studio has doubled down on its legal fight, and the rest of the NFTs were put on hold. But the owner of the scene one NFT is now sitting on an even rarer digital asset than anticipated. He can probably buy *a lot* of Royales with Cheese when this whole thing shakes out.

THE ONLINE BUZZ

"There's no amount of money in the world that would [make me give up] my original script…. It's not worth it to me to sell it, and it's not worth it to me to put it in a museum and have it sit in a glass case. But doing it this way…I think it's an exciting thing."

—*Quentin Tarantino speaking at crypto-art conference NFT.NYC, November 2, 2021*

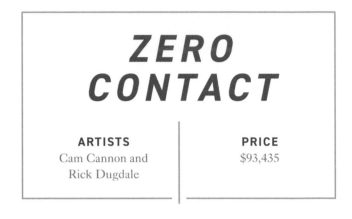

ZERO CONTACT

ARTISTS
Cam Cannon and
Rick Dugdale

PRICE
$93,435

DATE SOLD: September 24, 2021

SELLER OR PLATFORM: Vuele

THE TAKEAWAY: Your daily Zoom call heads to the movies.

WHAT AM I *ACTUALLY* LOOKING AT? Legendary actor and two-time Oscar winner Anthony Hopkins is not like other octogenarians who haven't figured out their cell phone and make comments on your thirst-trap Instagrams that say, "Looking good, Love, Grandpa." Instead, Hopkins starred in a COVID-era, Zoom-filmed movie, *Zero Contact*, as a tech titan who created teleportation technology. His five disciples must work together, à la Zoom huddle, to either shut down the invention before the world gets destroyed or use it for good.

You'd think getting the actors to go "off mute" seems like like enough of a challenge, but the director pushed the project a step further with its feature-film NFT release. Viewers got exclusive access to behind-the-scenes footage, crypto art, and the full-length feature. The initial eleven NFTs sold for over $90,000.

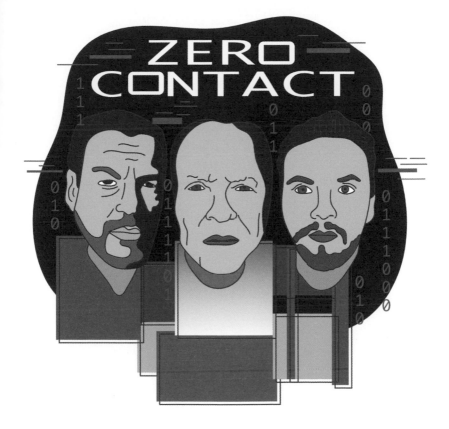

Making the film more user-friendly means that anyone can purchase an NFT of their own: for $59, viewers get an exclusive bundle, and $25 snags them the collector's edition. Who's excited to see a movie reenacting your company's Monday morning staff meeting? Anthony, *you're on mute!!*

WHAT MAKES IT SPECIAL? Vuele, an NFT video streaming platform, made a bet it could change the movie industry and get on the tech train with this movie release. Launched in 2021, the platform has plans to release even more full-length films direct to consumer, along with a bevy of movie memorabilia. Think Blockbuster, but make it digital. While this film didn't meet expectations in terms of profits, the platform is part of the growing experiment of cutting out the middleman (a.k.a. the studios and distribution companies) when it comes to giving profits directly to the people who worked on the film. So far, *Zero Contact* is the only film that's been released on the platform, but who knows what else Anthony Hopkins has up his sleeve.... Probably not another NFT movie though.

THE ONLINE BUZZ:

"Comes across more like an interminable conference call than the edge-of-the-seat thriller it's supposed to be."

—*Review in the* Los Angeles Times, *May 27, 2022*

"Worst Zoom meeting ever."

— *Review in* FilmWeek, *June 7, 2022*

MUSIC NFTS

NO SAD SONGS HERE, WHEN YOU'RE MAKING
MILLIONS ON THESE NFT MUSIC TRACKS.

KINGS OF LEON

WHEN YOU SEE YOURSELF

ULTRAVIOLET

STEVE AOKI'S HAIRY

ARTISTS	PRICE
Steve Aoki and Antoni Tudisco	$888,888.88

DATE SOLD: March 8, 2021

SELLER OR PLATFORM: Nifty Gateway

THE TAKEAWAY: "You can find me in the club, a bottle full of bub, and a wallet full of NFTs...."

WHAT AM I *ACTUALLY* LOOKING AT? Steve Aoki gets paid half a million dollars to show up and spin some records as a world-renowned club DJ. But when he dove into the NFT market with his own collection, he snagged almost twice that from a single piece. The NFT-loving musician and artist launched his 2021 project Dream Catcher, a collection of eleven NFTs which pair digital animations by visual artist Antonio Tudisco, set to Aoki's own musical mixes. The collection sold for $4.25 million, with the crown jewel being a 36-second video, "hairy." The clip features a psychedelic muppet grooving to some sick beats in front of a trippy pink background. Wonder what inspired that? (Umm, probably drugs.) The buyer certainly has

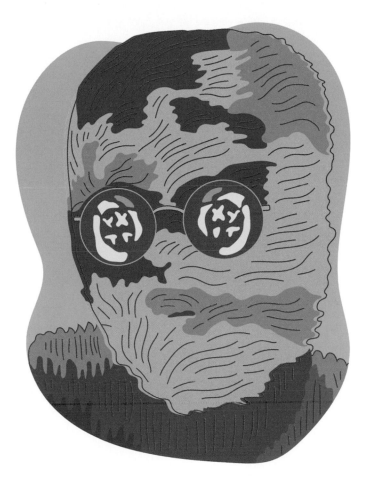

some spare cash on hand: former CEO of T-Mobile John Legere bought the clip for $888,888.88.

Aoki claims he's made more money on his NFT projects than he has over ten years of creating records in the music business. The biz can't be that bad, though: Aoki owns quite the portfolio of crypto himself, including five Bored Ape Yacht Club pieces, which are some of the priciest and most in-demand NFTs on the market today.

WHAT MAKES IT SPECIAL? Hairy broke the record for the most expensive sale on Nifty Gateway, selling for nearly $900,000 in 2021. The clip, which features Aoki's own music, is one of 11 designs by artist Antoni Tudisco. Aoki continued to hone his NFT skills after the success of Dream Catcher, launching a second collection in April 2021, called Neon Future. Beyond music, he's continued to invest in crypto, spending $859,000 on a cartoon NFT version of himself. Do we think he has some extra money to burn?

THE ONLINE BUZZ:

"NFTs gave me an opportunity to finally merge art, collectible culture, and music in a way I've never been able to realize before.... NFTs are a juggernaut that cannot be stopped. It will soon be normalized and be a structural pillar in our culture. If you're reading this now, you're early. Time to build, innovate and disrupt the entire space."

—*Steve Aoki in a press release, March 9, 2021*

SNOOP DOGG'S
B.O.D.R.

ARTIST
Snoop Dogg

PRICE
$5,000

DATE SOLD: February 18, 2022

SELLER OR PLATFORM: Gala Music

THE TAKEAWAY: This dog is barking up a very lucrative tree.

WHAT AM I *ACTUALLY* LOOKING AT? Snoop Dogg has his paws in many business ventures—from a decades-long music career all the way to collaborations with Martha Stewart, the OG does what he can to make a buck. He's been building his own collection of NFTs and releasing his own tracks through a relaunched Death Row Records. The original label counts hip-hop icons like Dr. Dre, Tupac, and Snoop Dogg himself in their trophy case, and now Snoop Dogg is top dog of that too: he bought the label in 2022 and has started releasing his own music as well as collaborations with other artists as NFTs.

Upon announcing his takeover of the legendary record label after his historic Super Bowl Halftime Show, Snoop released the album *B.O.D.R.*, short for *Bacc on Death Row*. The

album was released on traditional streaming platforms, and featured NFT stash boxes sold through Gala Music. For five D-O-double-Gs, each box contained one track from the album, and just twenty-five thousand were released. Snoop will be buying a lot of weed with the proceeds—in the six days after the release, the NFTs pulled in $45 million.

WHAT MAKES IT SPECIAL? Snoop Dogg is passionate about the control he and other recording artists can get from moving into the metaverse, and his recent forays into the NFT music scene prove that the medium is here to stay. Snoop has even more plans for Death Row and his metaverse music career: he's released an album, mixtapes with other hip-hop artists, and the first-ever NFT music video. He's also an avid collector of NFTs himself, with a portfolio valued at nearly $17 million. Looks like he'll be buying the gin and juice this round.

THE ONLINE BUZZ:

"I'm the CEO, the artist, all of the above. So, I'll just ask myself, 'Hey Snoop, is it okay if you do an NFT?' 'Sure, do whatever you like!' Everybody else gotta go to a label, a bunch of m—."

—*Snoop Dogg on the* Full Send *podcast, April 20, 2022*

"Who got that *B.O.D.R.* Stash Box!? Lemme know in the comments. More announcements coming soon! It's a gift that keeps on giving! @GoGalaMusic."

—*Tweet by Snoop Dogg, February 14, 2022*

KINGS OF LEON'S *WHEN YOU SEE YOURSELF*

ARTISTS	PRICE
Kings of Leon and YellowHeart	$2 million

DATE SOLD: March 20, 2021

SELLER OR PLATFORM: OpenSea

THE TAKEAWAY: If an album drops in the forest, erm, as an NFT…does anyone hear it?

WHAT AM I *ACTUALLY* LOOKING AT? Rock band Kings of Leon decided to try something new with their latest album drop, *When You See Yourself,* and released it as an NFT titled When You NFT Yourself, #dadjokes. The album was released on streaming platforms, and Kings of Leon superfans could get their hands on the NFT version, which came with a few extras: first dibs on concert tickets, first edition vinyl records, and the claim to owning the first NFT album ever launched.

But it seems like their fans would have preferred just lining up outside the Tower Records like old times—the band's NFT auction needed to be extended an additional week after sales of the NFTs remained low. Cue the tiny violin. Postauction, the

KINGS OF LEON

WHEN YOU SEE YOURSELF

album went on to hit the charts, rising all the way to #11 on the Billboard 200, and then rising even higher…into space. Their song "Time in Disguise" was sent with the crew of the world's first all-civilian space mission, aboard Space X's Inspiration4. The song marked the first NFT ever played in space, revealing just how far this mid-aughts band plans to go to remain relevant. "Oooo, your NFT's on fireeeeee."

WHAT MAKES IT SPECIAL? Kings of Leon went all out with their NFT launch—in addition to the NFT albums, special golden tickets were auctioned off that hooked mega fans up with a VIP experience: front-row seats for life, limo service, a concierge, and a hangout with the band themselves. The money all went to the band, instead of paying middlemen like streaming services and concert venues, and other fees that chip away at the bottom line. NFT music is yet another attempt for artists to gain control of where the music goes, and how the money flows. Overall, the band raked in nearly $2 million from their NFT sale and donated $500,000 to charity for concert crews impacted by the COVID-19 pandemic.

THE ONLINE BUZZ:

"Music has become great at selling everything except music. There's been a race to the bottom where, for as little money as possible, you have access to all of it. It's early stages, but in the future, I think this will be how people release their tracks: When they sell 100,000 at a dollar each, then they just made $100,000."

—*Josh Katz, CEO of Yellowheart, which collaborated with the band, in an interview with* Rolling Stone, *March 3, 2021*

VERDIGRIS ENSEMBLE'S BETTY'S NOTEBOOK

ARTIST	PRICE
Verdigris Ensemble	$375,000

DATE SOLD: May 8, 2021

SELLER OR PLATFORM: Async Art

THE TAKEAWAY: Amelia Earhart is singing the blues.

WHAT AM I *ACTUALLY* LOOKING AT? Who would have thought the tragedy of Amelia Earhart would inspire an NFT choir arrangement, yet here we find ourselves. Betty's Notebook tells the story of Earhart's final moments in the air, based on radio distress calls recorded by fifteen-year-old Betty Klenck in 1937. Klenck was allegedly listening to her family's shortwave radio when she heard the calls and began transcribing them into her notebook. While some believe this is the final record of Earhart's life, many have questioned the legitimacy of the calls, deepening the mystery around her death. The questions surrounding Earhart's tragic end have inspired countless conspiracy theories, and now a chorale by Texas-based group the Verdigris Ensemble.

The piece takes a bit of artistic license, re-creating Klenck's experience of hearing the calls. When the entire piece is performed, audiences hear the distress calls played through a radio, along with the choir singing, audio narration of Klenck reading from her journal, and a jazz piece imitating music that would have also been played on the radio at that time. The NFT version isolates these four elements, allowing the user to program their own musical experience. Plane crashes, but make it immersive!

WHAT MAKES IT SPECIAL? "Classical music" and "technology" aren't typically used in the same sentence, yet the Verdigris Ensemble is leading the way when it comes to dragging classical music into the twenty-first century. A bonus is that they're making a lot of money while doing it: the ensemble raised $375,000 for their production, which took three years to record and complete. The owner of the NFT now has the rights to the master track—think Taylor Swift, à la *Red (Taylor's Version)*. If you don't have hundreds of thousands of dollars in iTunes gift cards to spend to listen to the track yourself, the choir plans to embark on a concert tour to share the experience with even more listeners.

THE ONLINE BUZZ:

"Betty's Notebook was just the beginning of classical music NFTs."

—*Tweet by Verdigris Ensemble, October 3, 2021*

"Betty's Notebook has essentially given birth to crypto music, paving the way for a new and innovative medium of creating and experiencing music."

—*Anand Venkateswaran, who purchased the NFT, in an interview with* The Hindu, *May 13, 2021*

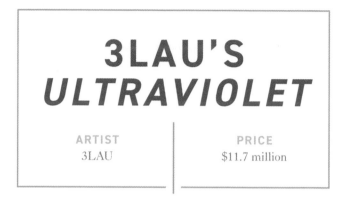

3LAU'S *ULTRAVIOLET*

ARTIST
3LAU

PRICE
$11.7 million

DATE SOLD: February 28, 2021

SELLER OR PLATFORM: Dshop

THE TAKEAWAY: Feel the bass drop…along with your savings account balance.

WHAT AM I *ACTUALLY* LOOKING AT? Musician, DJ, and electronic music producer Justin Blau can add another title to his illustrious resume: NFT record breaker. Blau, known at "da cloobs" as 3LAU, originally released his album *Ultraviolet* in 2018. Three years later, he uploaded the tracks onto the blockchain. The thirty-three-piece collection sparked a bidding war and collectively made $11.7 million in sales. The top bidder spent a record-breaking $3.6 million for a special edition vinyl, unreleased music, and the opportunity to create a track with 3LAU himself. Drop the bass—and a few million bucks.

3LAU has been a proponent of crypto for nearly a decade and has blended his interest in techno music with the tech world. The DJ counts tech bros like the Winklevoss twins as

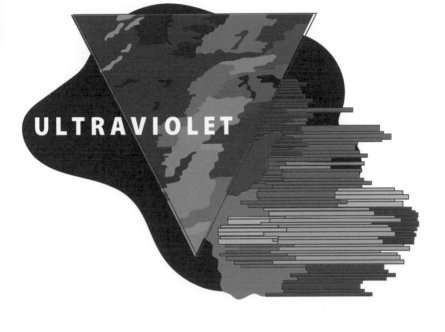

close friends, after the pair introduced him to the potential of crypto with their cryptocurrency exchange platform, Gemini. 3LAU has since launched and hosted the first-ever blockchain-powered music festival, Our Music Festival, in 2018. Attendees paid for everything in crypto and danced all their money away. What's next for this business school dropout turned crypto king? (Probably more ecstasy.)

WHAT MAKES IT SPECIAL? *Ultraviolet* made an impressive $11.7 million in sales of just thirty-three NFTs. The top bidder spent the highest price ever paid for a single NFT—at the time, $3.6 million—and, in return, got to collaborate with the famous DJ on his very own GarageBand fantasy. Blau is continuing to expand the idea of how artists can make money off their music—with no intermediaries like studios and record labels, all those profits, and the rights to the tracks, stay with the artist.

THE ONLINE BUZZ:

"History has been made! The auction for the world's first tokenized album has finished. Built by @OriginProtocol & powered by #Dshop, @3LAU sold 33 unique NFTs for a total of $11,684,101. This is a new record in a single #NFT auction."

—*Tweet by Origin Protocol, February 28, 2021*

"We were all cheering, and then everyone just stopped talking. Trust me, I didn't know it was going to go this high."

—*Justin Blau, a.k.a. 3LAU, interview with* Forbes *magazine, March 3, 2021*

POLITICAL NFTS

THE ONE THING EVEN AMERICANS CAN ALL AGREE ON? NFTS ARE PRETTY WEIRD.

```
#import <ctype.h>;
#import <objc/Object.h>;
#import <objc/typedstream.h>;
#import <appkit/appkit.h>;
#import "Anchor.h"
#import "HTUtils.h"
#import "HTParse.h"
#import "HyperText.h"
#import "HyperManager.h"
@implementation Anchor:Object
static HyperManager *manager;
static List * orphans;        // Grand list of all anchors with no parents
List * HTHistory;             // List of visited anchors
+ initialize
{
  orphans = [List new];
  HTHistory = [List new];
  [Anchor setVersion:ANCHOR_CURRENT_VERSION];
}
+ setManager:aManager;
  return self;
}
//
```

CLOCK

ARTISTS	PRICE
Pak and Julian Assange	$52.7 million

DATE SOLD: February 9, 2022

SELLER OR PLATFORM: censored.art

THE TAKEAWAY: A new way to pay off your legal fees.

WHAT AM I *ACTUALLY* LOOKING AT? Clock continuously depicts the number of days Julian Assange—activist, hacker, and founder of WikiLeaks—has spent in jail, stemming from his most recent arrest in 2019. Assange is currently serving a five-year sentence in a London maximum-security prison, after skipping bail related to a previous legal battle. But Clock's countdown could become much, much longer—Assange is still wanted in the United States on seventeen charges of espionage related to his work with WikiLeaks, when he published classified military documents involving the Iraq War. He could face up to 175 years in prison if extradited and put on trial.

Assange has been wading through the legal system for years now, and those expensive High Street lawyer fees certainly

ONE THOUSAND THIRTY FIVE

add up. Assange collaborated with NFT artist Pak to create Clock, and the activist's rampant support group was quick to snatch up the piece, paying nearly $53 million. Nope, they didn't get a gold Rolex—just a computer file with some rapidly accumulating numbers.

WHAT MAKES IT SPECIAL? While most NFTs are held by individual owners, a collective of ten thousand people pooled their money together before the clock struck midnight (whoops, wrong story), securing the rights to the NFT and giving Assange some much-needed financial relief. The funds went to the Wau Holland Foundation, which has been paying for Assange's legal fees and managing his defense since 2011. With $52.7 million filling up the coffers, Assange won't be calling 1-800-LAWYER anytime soon.

THE ONLINE BUZZ:
"And @AssangeDAO acquires Clock for 16593 ETH. 100% will go to Wau Holland Foundation that supports Julian Assange's defense."

—*Tweet by Pak, February 9, 2022*

"Julian has been silenced. He has had no voice for the last three years. He has been detained for eleven years. His freedom is sort of linked to this NFT in a way that we can tell the story of how he's been censored, how he is not free.... It's also a chance for people to give to a good cause and receive something in return, like an NFT or artwork by this amazing creator, Pak."

—*Gabriel Shipton, Julian Assange's brother, in an interview with tech journalist Naomi Brockwell*

CROSSROAD

ARTIST	PRICE
Beeple	$6.6 million

DATE SOLD: February 24, 2021

SELLER OR PLATFORM: Nifty Gateway

THE TAKEAWAY: When a loser becomes a big winner.

WHAT AM I *ACTUALLY* LOOKING AT? Crossroad imagines two scenarios: one where Trump won the 2020 election and one where he lost the 2020 election. The NFT that sold contained two versions: an animation of Trump if he had won, which, since that did not happen by the grace of God, has never been revealed. The second scenario featured a bloated, naked, tattoo- and sticker-covered Trump lying face down as people walked by him, unaware of his existence. If only.

While the NFT was originally sold on November 1, 2020, for $66,000, even Beeple could never have predicted how much messier the real world would be compared to his virtual one. The postelection mayhem, insurrection, and endless Twitter temper tantrums showed that Trump was, unsurprisingly, a bit of a sore loser. But while the news was bad for Trump, it was

good for Beeple—the NFT was resold in February for one hundred times its original price, for a jaw-dropping $6.6 million. Just like the nightmare of that election, the appeal of this NFT just kept going on and on and on.

WHAT MAKES IT SPECIAL? This NFT is known for its rapid increase in value. Beeple got a 10 percent cut of both sales too, kicking off a gangbuster 2021 for the artist and cementing him as an NFT demigod. After Crossroad, Beeple sold Everydays: The First 5000 Days for $69 million in a Christie's auction. Perhaps he can spare a few coins for Trump's legal defense? Though in this case, it might be better to hoard.

THE ONLINE BUZZ:

"The #1/1 from beeple's first NG drop has just resold on the secondary market for $6.6 million. History has just been made."

—*Tweet by Nifty Gateway, February 24, 2021*

"At the time it was like, oh my God, I sold a piece for 66,000. It was just, like, insane."

—*Beeple interview with* Insider, *March 15, 2021*

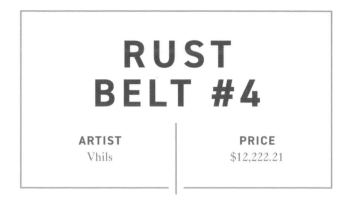

RUST BELT #4

<table>
<tr><td>**ARTIST**
Vhils</td><td>**PRICE**
$12,222.21</td></tr>
</table>

DATE SOLD: June 22, 2021

SELLER OR PLATFORM: Nifty Gateway

THE TAKEAWAY: You can blow up the art world by blowing up a building.

WHAT AM I *ACTUALLY* LOOKING AT? Portuguese visual artist Alexandre Farto, known as Vhils, has spent his art career defacing buildings in the name of art, eschewing pen, paper, and canvas for chisels, drills, and explosives. Over the course of a demolition, Vhils reveals portraits of people from marginalized communities. Rust Belt #4 is part of a larger work, The End of the Industrial Era, and Vhils returned to his hometown for inspiration. The explosion involved a building in Barreiro, a rust belt town in Portugal. The first blast revealed an archival image of a factory worker from the area, before the entire building exploded into a cloud of dust.

Vhils took the video using a ballistic camera, and the explosion took two seconds. The video reveals a slow-motion

version of the blast, which Vhils released as an NFT, along with chunks of debris, labeled Detritus. The piece represents the natural life cycle of the universe, as structures are created, destroyed, and then built once again. But like any reno, it doesn't come cheap: Rust Belt #4, which shows the entire explosion over two and a half minutes, sold for over $12,000, and nearly twenty pieces of Detritus sold for thousands of dollars each.

WHAT MAKES IT SPECIAL? Vhil's work reveals the churn of industrialization, as he burns and blows up the world around him. Unlike other NFTs that are created digitally using computers and technology, Vhils relies on the physical to create his virtual art. In addition to Rust Belt #4 and the Detritus NFTs, Vhils has blown up factories, set fire to abandoned buildings, and exploded a building with the word LIFE carved into the side. "Once you were dust, and to dust you shall return."

THE ONLINE BUZZ:

"The explosions…serve as a metaphor of the natural progression of existence in the universe, a cycle of creation, destruction, and new creation, driving us forward on a continuous quest to respond to our needs and comfort. But at what cost? An artifact of a new digital industrial era that is approaching at full speed, in a timeframe and territory where our presence will be progressively less evident."

—*Instagram post by Vhils, April 7, 2021*

THIS CHANGED EVERYTHING

ARTIST	PRICE
Tim Berners-Lee	$5.4 million

DATE SOLD: June 30, 2021

SELLER OR PLATFORM: Sotheby's

THE TAKEAWAY: A whole lotta numbers sold for a whole lotta money.

WHAT AM I *ACTUALLY* LOOKING AT? The World Wide Web—can anyone remember a time when you didn't spend your one precious life scrolling your ex's sister's boyfriend's brother's Facebook feed at 3 a.m., or Googling, "How would my face look with bangs" (probably bad)? The man to thank for this bottomless pit of knowledge and distraction is Sir Tim Berners-Lee, a British computer scientist who wrote the code that led to the creation of the internet in 1989. This Changed Everything is the original time-stamped source code—9,555 lines of gibberish that transformed the world into the internet-fueled hellfire we know and love today.

```
#import <ctype.h>;
#import <objc/Object.h>;
#import <objc/typedstream.h>;
#import <appkit/appkit.h>;
#import "Anchor.h"
#import "HTUtils.h"
#import "HTParse.h"
#import "HyperText.h"
#import "HyperManager.h"
@implementation Anchor:Object
static HyperManager *manager;
static List * orphans;      // Grand list of all anchors with no parents
List * HTHistory;           // List of visited anchors
+ initialize
{
  orphans = [List new];
  HTHistory = [List new];
  [Anchor setVersion:ANCHOR_CURRENT_VERSION];
}
+ setManager:aManager;
  return self;
}
//
```

This code was already available in the public domain (a.k.a., free, for everyone), but call it an NFT and suddenly that block of code is worth a block of cash. The winning bidder got a veritable goody bag of treats: for $5.4 million, the buyer received the code signed by Berners-Lee himself, an animated version of the code, and a poster of the code. Who needs Posters.com anyway? Berners-Lee planned to use the money to fund charity initiatives. Sounds like this tech-bro philanthropy changed…nothing?

WHAT MAKES IT SPECIAL? Sotheby's leaned into the nostalgia factor of the world's first website, calling it the auction house's "first historical artifact relating to this landmark moment to ever be sold." Just like so many of the scams the World Wide Web has since borne, selling code may just take the cake.

THE ONLINE BUZZ:

"Over the past several centuries humankind has seen a succession of paradigm shifts that have brought us forward into the modern era; Galileo's proof of heliocentricity, Gutenberg's invention of the printing press, and Einstein's theory of relativity to name but a few, but none has had the seismic impact on our daily lives as the creation of the World Wide Web."

—*Press release from Cassandra Hatton, VP, global head of science and popular culture at Sotheby's*

"I'm not even selling the source code. I'm selling a picture I made with a Python program that I wrote myself, of what the source code would look like if it was stuck on the wall and signed by me."

—*Sir Tim Berners-Lee interview with* The Guardian, *June 23, 2021*

LONGYEARBYEN WARMING

ARTIST
BREAKFAST

PRICE
$85,000

DATE SOLD: November 30, 2021

SELLER OR PLATFORM: ArtRepublic and SuperRare

THE TAKEAWAY: The Earth gets hotter; the art gets weirder.

WHAT AM I *ACTUALLY* LOOKING AT? Longyearbyen Warming is a video art installation turned NFT with a purpose: showing the impact climate change is having on the world. Longyearbyen, Norway, is the fastest-warming city in the world, and as temperatures increase compared to historical averages, the art piece is covered in more gold discs. BREAKFAST used Flip-Discs, which mechanically flip back and forth using electromagnets. Each disc reacts in real time to temperature fluctuations and can also be interactive—as people get closer to the art, the gold pieces outline their shape and movements, representing the human responsibility toward climate change.

The original piece debuted at the United Nations Climate Change Conference in 2021, after global leaders gathered to…

do nothing about climate change. Ineffective leadership, but make it art! The owner of the NFT not only got the digital version, but the physical piece of art too. Because we all need even *more* reminders that the Earth is melting. Ironically, NFTs and cryptocurrencies have been criticized for the sheer amount of energy they require to create, emitting Earth-warming carbon dioxide. An energy-sucking piece of art, causing global warming, making a statement about the impact of global warming?! Like our flummoxed reaction to what we can possibly do to prevent the Earth's gradual melting…no one seems to get it.

WHAT MAKES IT SPECIAL? BREAKFAST is an art studio that produces kinetic art installations, often interactive pieces where individuals can become "part of the art." They're also "part of the reason the world is on fire," so a global-warming-centric piece seems like just the thing to bring awareness to this ever-dire scenario. Since Longyearbyen Warming sold for $85,000 in 2021, the team behind BREAKFAST went on to create several more climate-change-themed NFTs that were picked up by Christie's, using the same patented techniques.

THE ONLINE BUZZ:

"If you're going to jump onto the #NFT bandwagon, there are worse ways to do it. Joining some really great artists to all release our first NFTs."

—*LinkedIn post by Andrew Zolty, artist and founder of BREAKFAST, November 2021*

SPORTS NFTS

THESE SPORTS NFTS WIN THE CHAMPIONSHIP
FOR CRAZIEST INVESTMENT STRATEGY.

LEGENDARY LEBRON JAMES

ARTISTS	PRICE
NBA and Dapper Labs	$208,000

DATE SOLD: February 22, 2021

SELLER OR PLATFORM: NBA Top Shot

THE TAKEAWAY: King James's NFT isn't just legendary; it's a slam dunk for investors!

WHAT AM I *ACTUALLY* LOOKING AT? Clips of LeBron James dunking a basketball are a dime a dozen—the second-best basketball player of all time (behind the GOAT, Michael Jordan) has scored nearly forty thousand points over his career so far. Yet mega fans are shelling out megabucks to claim they own these pivotal sports moments, and the NBA is cashing in. Top Shots are digital playing cards of legendary sports moments, and they've pulled in more than a billion dollars in sales so far, selling clips that can be easily found on ESPN for free.

But real fans always go the extra mile, and a group of investors put their pennies together to spend $208,000 on a 2019 dunk shot by James, making it the most expensive clip sold on

Top Shot at the time. Making money off sports memorabilia has always been a slam dunk, and with an endless library of iconic sports moments at Top Shot's disposal, nothing is out of bounds when it comes to the cash fans are willing to spend. Instead of saving those iconic moments as trading cards in a laminated binder that lives untouched in a basement, they can live untouched on the blockchain. Something to pass down to the kids!

WHAT MAKES IT SPECIAL? This Legendary LeBron James clip is just one of many on the NBA Top Shot marketplace, signaling a high demand for virtual sports memorabilia. The investors came together as a team to purchase the video—and teamwork makes the dream work. The clip broke records for the most expensive Top Shot clip sold. At $208,000, it's just a tad more expensive than courtside seats.

THE ONLINE BUZZ:

"ALL HAIL THE KING @YoDough scooped up this Legendary LeBron James Moment from our Cosmic Series 1 set for $208,000 This Moment is from our first Legendary set ever minted the top acquisition for any NBA Top Shot Moment…so far. Congrats on the nice pickup!"

—*Tweet from NBA Top Shot, February 22, 2021*

"Just broke the @nba_topshot record!! Spent $208k on the GOAT @KingJames moment….

Long live the king!!!! FRONT PAGE."

—*Tweet from buyer YoDough, February 22, 2021*

LEGIA WARSAW

ARTIST	PRICE
Capital Block	Unreleased

DATE SOLD: February 11, 2022

SELLER OR PLATFORM: Various

THE TAKEAWAY: Leave it to the jocks to explain NFTs to everyone else.

WHAT AM I *ACTUALLY* LOOKING AT? Legia Warsaw is a top football team (that's soccer for us Americans) in the European circuit, and while you'd think their hands would be full batting away flying soccer balls, they've dipped a cleat onto the cryptocurrency pitch. The Polish team was the first European soccer club to establish a partnership with an NFT agency, Capital Block. The pairing will help the team strategize what sorts of sports-related memorabilia and game clips they should turn into NFTs, the platforms they should utilize, and other ways to connect with fans and get them to sign on. Educating those fans around the benefits and perks of NFTs is a big part of Capital Block's mission too—because no one is more eager to learn about the complex realities of cryptocurrency than soccer fans at the pub, ten beers deep.

Legia Warsaw, the most successful Polish football club in history, has seen great success on the soccer field—which means there's money to be made once those boys head to the locker room. Capital Block is banking on the idea that the success of the team on the field will translate to the virtual one, and that their rabid fans will follow. The agency will get a cut either way, as they also signed on as a team sponsor when they made the deal. New digital jerseys for everyone!

WHAT MAKES IT SPECIAL? While many professional sports teams in Europe have partnered with cryptocurrency platforms, Legia Warsaw is the first to be represented by an official NFT agency. The partnership will help them monetize their memorabilia and get fans cheering from the stands (and spending money on more than just beer and brats). NFTs can help athletes connect to fans, engage in virtual meet and greets, and host other interactive experiences. But mostly…it's a marketing opportunity. Maybe the team should just focus on kicking the ball into the thing. Seems easier?

THE ONLINE BUZZ:

"We are thrilled to be working with Legia Warsaw and enabling its fans to get even closer to the club they love through NFTs…. We'll now get working on NFTs that mark and represent some of the most iconic players and moments in the club's history, as well as ensuring that Legia NFTs have utility to its fans…. Legia Warsaw is the first and currently only European club with an official NFT agency: every other football club on the continent is now behind the Polish league champions."

—*Tim Mangnall, CEO of Capital Block, in a press release, February 11, 2022*

MICHAEL JORDAN'S 6 RINGS

ARTISTS	PRICE
Michael Jordan and Jeffrey Jordan	$187

DATE SOLD: March 4, 2022

SELLER OR PLATFORM: Magic Eden

THE TAKEAWAY: Selling bulls…or spewing bull? Hard to tell.

WHAT AM I *ACTUALLY* LOOKING AT? Michael Jordan is one of the most successful and highly decorated athletes of all time—he scored nearly thirty-three thousand points over his fifteen-year career and led the Chicago Bulls to championship victory six times. Those victories—and the ice that came with them—influenced Jordan's NFT collection, 6 Rings. The 3D bull heads were inspired by the championship rings that decorate Jordan's massive mitts and were put on the Solana marketplace for 2.3 SOL apiece, symbolizing his jersey number, 23.

Jordan teamed up with his son Jeffery to launch their own NFT marketplace, HEIR, in 2021. The rings were the pair's first NFT drop, and all five thousand available NFTs sold out within

a day. While Jordan initially planned to sell ten thousand NFTs in his auction, he slashed the collection in half due to lack of interest. Hey, his '90s heyday was like, thirty years ago—cut the guy some slack! The rings were sold for around $200 apiece but have seen a brisk biz on the resale market. One motivated seller asked for a whopping $337,000, a 154,000 percent markup on the original piece. That guy should work for StubHub!

WHAT MAKES IT SPECIAL? Jordan hopes to imitate the locker-room feel with the HEIR marketplace. Buyers who snagged a ring in the initial sale get access to exclusive content and merchandise, through inclusive communities called Huddles. That inclusivity will be a major selling point: the father-son duo eventually wants to offer limited edition "seats" that would give members a front-row view of the virtual arena, with even more exclusive access to future NFT drops and immersive experiences. Maybe Michael Jordan Getting Mad at his Teammates should be the next drop?

THE ONLINE BUZZ:

"The entire team at HEIR is incredibly excited about the potential NFTs and Web3 have in connecting fans and athletes."

—*Jeffrey Jordan interview with* Decrypt, *March 3, 2022*

"I can accept failure; everyone fails at something. But I can't accept not trying."

—*Michael Jordan in his 1994 book,* I Can't Accept Not Trying: Michael Jordan on the Pursuit of Excellence

TONY HAWK'S 540-DEGREE OLLIE

ARTISTS	PRICE
Tony Hawk and Ondrej Zunka	$49,840.13

DATE SOLD: May 12, 2021

SELLER OR PLATFORM: Ethernity Chain

THE TAKEAWAY: This NFT was faster cash than a GoFundMe for knee surgery.

WHAT AM I *ACTUALLY* LOOKING AT? Skateboarding legend Tony Hawk attempted to freeze time (and prevent future injury) with his NFT—a video capturing the last time he'd ever attempt an Ollie 540. The trick, where a skateboarder rotates on his board 540 degrees, or one and a half times around, without holding onto the board with his hands, was originally perfected by Hawk in 1989. Instead of hanging up his neon knee pads and unplugging the VCR, Hawk has continued to push himself to the *x-treme*, and skate right into the NFT market.

Hawk claimed the trick was getting too scary as he got older (something about the spinning through the air with no

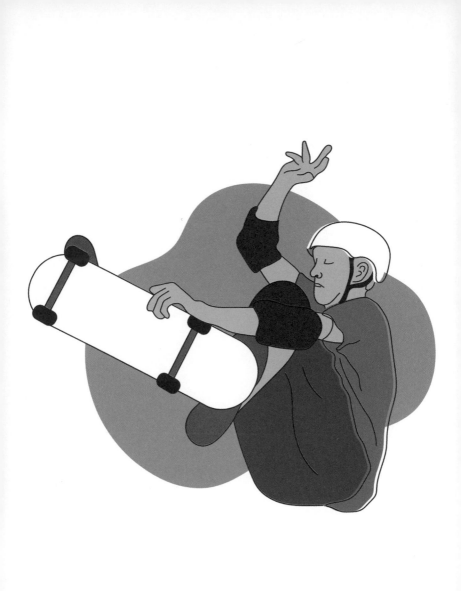

hands thing…), and decided to film the trick one last time, selling the video as an NFT. Hawk's video was part of a larger collection of NFTs created with digital artist Ondrej Zunka, including an NFT graffiti wall, NFT skateboards, and even an NFT sneaker signed by Tony Hawk himself. Gnarly brah!

WHAT MAKES IT SPECIAL? Hawk is another high-profile athlete cashing in on the NFT craze. The pro athlete snagged nearly $50,000 for his video. The platform he sold it on, Ethernity Chain, gives its sellers the option to tap into their philanthropic side with a percentage sent to a charity of their choice.

THE ONLINE BUZZ:

"They've gotten scarier in recent years, as the landing commitment can be risky if your feet aren't in the right places. And my willingness to slam unexpectedly into the flat bottom has waned greatly over the last decade. So today I decided to do it one more time…and never again."

—*Instagram post by Tony Hawk, March 17, 2021*

"Kinda sad. I'm like a little sad. I've never had much finality to anything, but that was definitely the last one I'll ever do."

—*Tony Hawk in his video landing his last Ollie 540, March 17, 2021*

TIGER WOODS'S ICONIC FIST PUMPS

ARTIST	PRICE
Autograph	$80

DATE SOLD: April 7, 2022

SELLER OR PLATFORM: Autograph

THE TAKEAWAY: You know you're a big deal when they make a golf course that looks like your face.

WHAT AM I *ACTUALLY* LOOKING AT? Tiger Woods has plenty to celebrate. Over the course of a groundbreaking golf career, Woods has eighty-two PGA championship titles to his name, including a historic five Masters wins. His record is second only to Jack Nicklaus, who won six Masters titles over a twenty-five-year career. Woods's latest NFT collection honors his determination on the course with a collection of his iconic fist pump moments after cinching the shot. Each of the five videos reveals Woods making a winning shot, before zooming out to an aerial image of a golf course designed to look like Woods's face and body, with his fist raised in triumph.

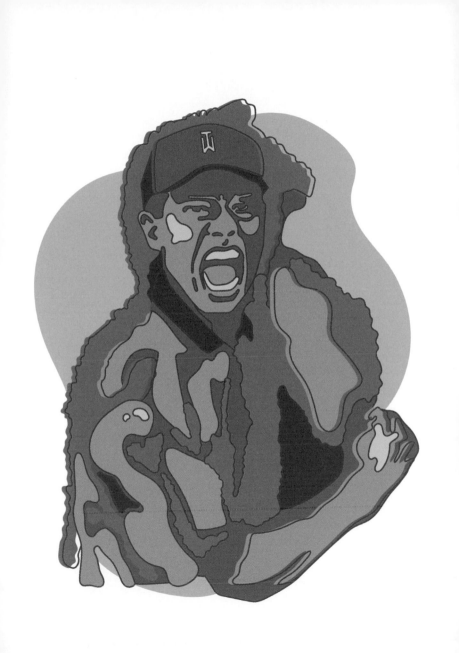

While Woods has stumbled both personally and professionally in recent years, plagued by relationship issues, multiple car accidents, and various injuries, the launch of these NFTs coincided with his highly anticipated return to the Masters' greens in 2022. The collection included 16,600 NFTs, which sold for $80 a pop—collectors who purchased all five versions of the pumps also snagged a platinum "Immortal Statue" of the famous athlete. The only thing missing was an actual win—while Woods fell far off the leaderboard in 2022, his triumphant moments are now immortalized on the blockchain. Who knew his biggest dream would be having a sand trap on his face?

WHAT MAKES IT SPECIAL? Woods's fist pump NFTs are the second collection he's launched on Autograph, an NFT marketplace started by another sports legend, Tom Brady. The platform hosts a variety of famous sports stars shilling their professional moments for monetary gain—Woods joins Derek Jeter, Wayne Gretzky, Naomi Osaka, and others who have released digital collectibles. What makes these NFTs unique from other sports-themed offerings is that each NFT is digitally signed by the athletes themselves, who scrawl their signatures using an Apple Pencil. Quite a step up from a Sharpie!

THE ONLINE BUZZ:

"Tiger Woods is bigger than the game of golf. His dominance and cultural legacy loom large over the courses that have hosted him. Commemorating his unforgettable celebrations, the @TigerWoods Iconic Fist Pumps Collection launches for the public April 7. See you on the course."

—*Tweet by Autograph, April 1, 2022*

UNCATEGORIZED NFTS

LAST BUT NOT LEAST, HERE YOU'LL FIND A
GRAB BAG OF NFTS THAT DEFY ALL OTHER LABELS.

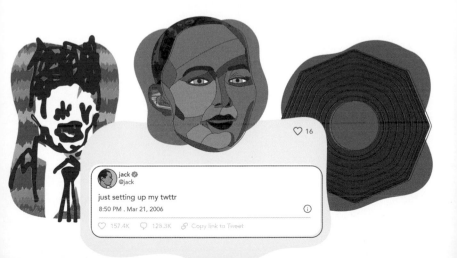

A COIN
FOR THE
FERRYMAN

ARTIST	PRICE
XCOPY	$6.03 million

DATE SOLD: November 4, 2021

SELLER OR PLATFORM: SuperRare

THE TAKEAWAY: You'll either have a seizure looking at it, or a seizure once you see how much it sold for.

WHAT AM I *ACTUALLY* LOOKING AT? A Coin for the Ferryman is one of the earliest works by crypto artist XCOPY, a pseudonym for the London-based creator who has sold millions of dollars in NFT and crypto art since 2017. Unlike many NFTs, which feature characters or have algorithm-generated characteristics over a thousand-piece collection, A Coin for the Ferryman is in GIF form, and features a line drawing of a despairing face over a background of TV-static-style colors. When the NFT was originally sold in 2018, the owner purchased it for just $139—three years later, the piece ballooned in price and sold for a whopping $6.03 million. Talk about a return on investment!

XCOPY's art features themes of death and dystopia—you know, all the cheerful stuff. The title of the piece references Greek mythology, where a coin for the ferryman would be a payment or bribe to those who would transport souls between the world of the living and the world of the dead. For six million bucks, the buyer must have a lot of enemies he's looking to deal with....

WHAT MAKES IT SPECIAL? XCOPY is one of the pioneers in the NFT and crypto art space, and his art has demanded a high price. Since creating A Coin for the Ferryman, XCOPY has churned out even more Microsoft Paint–style artworks and made $23 million in ten minutes with a 2022 NFT drop titled MAX PAIN. No need to live in agony—those funds should afford him some Tylenol.

THE ONLINE BUZZ:
"This s— sells for six million? I've seen diarrhea with more work put into it."

—*Tweet by @Starr_Saylor in response to a tweet announcing the sale of A Coin for the Ferryman, November 4, 2021*

DECENTRALAND'S FASHION STREET ESTATE

ARTISTS
Ari Meilich and
Esteban Ordano

PRICE
$2.4 million

DATE SOLD: November 23, 2021

SELLER OR PLATFORM: Decentraland Marketplace

THE TAKEAWAY: Shouldn't we consider solving the housing crisis first??

WHAT AM I *ACTUALLY* LOOKING AT? Time to pack up the moving van and head to Decentraland, an immersive virtual world where users buy plots of land to build their own online universe. This digital environment, known as the metaverse, has been under development since 2015, and opened to the public in 2020. Users can buy land, visit buildings, offices, and stores, and walk around and engage with other virtual avatars. Think real life but without social distancing or engaging with actual human beings. Paradise!

Like any real estate boom, this market is hot. In 2021, Fashion Street Estate, a stretch of land in Decentraland, sold for a whopping $2.4 million to a group of investors. Fashion Street

Estate consists of 116 plots of land, rife for retailers to snatch up and sell their virtual wares. The investors in the land said they plan to use it to host retail events and fashion shows, selling virtual versions of what you'd get essentially for free at Forever21.

WHAT MAKES IT SPECIAL? When it was purchased for an insane $2.4 million, Fashion Street Estate was the most expensive piece of land sold in the metaverse. And as more brands feel the pressure to engage with their customers by any means possible, they're heading to the metaverse to stake a claim. Major retailers like Nike and Louis Vuitton and media companies like Facebook are all flocking to the metaverse for the opportunity to sell more stuff to deep-pocketed consumers. Digital real estate works as another way to advertise, while providing immersive online experiences for users. Here are some words of advice for anyone looking to enter the metaverse: *go outside instead.*

THE ONLINE BUZZ:
"Hopefully, they put a Costco in."

—*Tweet by @WVMDRE, November 22, 2021*

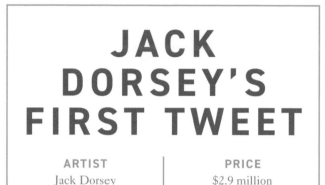

JACK DORSEY'S FIRST TWEET

ARTIST	PRICE
Jack Dorsey	$2.9 million

DATE SOLD: March 22, 2021

SELLER OR PLATFORM: Valuables by Cent

THE TAKEAWAY: "Just setting up my" bank account, amirite? Hashtag insanity.

WHAT AM I *ACTUALLY* LOOKING AT? Tweets: thoughtless little musings that have clogged up the internet, ruined democracy, and…made a superrich tech bro *even richer*. When Jack Dorsey founded Twitter in 2006, he penned his very first tweet: "just setting up my twttr." This revelatory, spell-check-free blip resurfaced fifteen years later as an NFT and sold for a whopping $2.9 million. So, will the lucky winner have exclusive rights to such poetic musings? Well…not so fast. The tweet still exists on the platform. The seller just gets the equivalent of a read receipt and a digital autograph from Dorsey himself. Seems… not worth it at all.

♡ 16

jack ✔
@jack

just setting up my twttr

8:50 PM . Mar 21, 2006 ⓘ

♡ 157.4K 💬 128.3K 🔗 Copy link to Tweet

However, the NFT joke is on *this guy*. The buyer (wait for it…a tech bro) tried to resell the tweet about a year later, hoping to exponentially grow his profit by listing it for $48 million. But like many crypto investors, he had no idea what he was doing, and the tweet tanked in value, selling for just $280. At least the original profit went to a good cause; Dorsey said he planned to donate the funds from the original sale to GiveDirectly, a charity that gives cash to those in poverty. Tweet becomes NFT, becomes cryptocurrency, becomes cash. What's next? The return of Myspace?? Seems…less likely, TBH.

WHAT MAKES IT SPECIAL? Dorsey is #procrypto, and his NFT aligned with the virtual frenzy of seeking out shiny new, yet old, things. However, unlike other NFTs that bank on their uniqueness to soar in value, the tweet itself is not special (#sorrynotsorry). In Twitter's heyday, nearly six thousand tweets were sent out per second. Get back to the keyboard, Dorsey!

THE ONLINE BUZZ:

"By bidding on Jack Dorsey's first tweet of history…I wanted to emphasize the importance of NFTs on [the] future of crypto and tech sphere. I wanted to encourage involving in charities in the crypto space."

—*Sina Estavi, who purchased the tweet, in an interview with* CNBC Make It

"Ending this March 21st Will immediately convert proceeds to #Bitcoin And send to @GiveDirectly Africa Response Thank you, @sinaEstavi."

—*Tweet by Jack Dorsey, March 9, 2021*

QUANTUM

ARTIST	PRICE
Kevin McCoy	$1.4 million

DATE SOLD: June 10, 2021

SELLER OR PLATFORM: Sotheby's

THE TAKEAWAY: Everything that came after this NFT is all this guy's fault.

WHAT AM I *ACTUALLY* LOOKING AT? Quantum is widely regarded as the very first NFT ever created. Artist Kevin McCoy minted the original version of the piece back in 2014, years before the crypto frenzy spiraled out of control. And the piece itself is a bit of a frenzy too—the video art has a screen-saver-esque vibe, with a pixelated octagon changing colors on a five-second loop. Hey, not only did this guy create the first NFT, but he also opened the door to adult coloring book themes that we know and love today.

Sotheby's nabbed the NFT for their first-ever Natively Digital auction, selling the piece for $1.4 million. But drama soon followed, when a Canadian company claiming to have the rights to the NFT way back in 2014 sued Sotheby's.

Cue the clattering champagne glasses, but the lawsuit unfolded because McCoy neglected to renew his membership to Namecoin, a blockchain software he initially used to create the piece. This little bureaucratic slip meant that the company that owns Namecoin technically owned Quantum, despite it being listed and sold to a new owner. The suit is pending as of 2022. A new wrinkle in the art heist genre!

WHAT MAKES IT SPECIAL? Quantum is the first NFT ever created, and its sale established Sotheby's foot in the door of digital art. McCoy has said he was inspired to create a one-of-a-kind version of his art after being rejected from the gallery and museum scene, which traditionally highlights physical art pieces like painting and sculpture. In the process of sticking it to the man, he opened a new universe to artists to display their work—and profit from it. With pending litigation surrounding the sale, he may want to at least hire a manager to handle his emails, so he can stick to the art.

THE ONLINE BUZZ:

"So happy to own the first ever NFT, Quantum, from @mccoyspace. A piece of history. Let's see how we can continue its story."

—Tweet by SillyTuna, current owner of Quantum, June 10, 2021

"For a while I was thinking that Quantum should go into the collection of a museum like MoMA but now, I'm like f— it. I hope it flies like a giant flag above a maxi's citadel in the metaverse."

—Tweet by artist Kevin McCoy, April 29, 2021

SOPHIA INSTANTIATION

ARTIST	PRICE
Andrea Bonaceto	$688,888

DATE SOLD: March 25, 2021

SELLER OR PLATFORM: Nifty Gateway

THE TAKEAWAY: Artificial intelligence takes over the art world.

WHAT AM I *ACTUALLY* LOOKING AT? Sophia Instantiation is the first NFT digital artwork created by a robot. Sophia the robot is a Hong Kong creation invented in 2016 as a "social humanoid robot." Since then, she's partaken in humanoid activities, like walking in Fashion Week, receiving her Saudi Arabian citizenship, getting interviewed on *The Tonight Show Starring Jimmy Fallon*, and making hundreds of thousands of dollars off her NFT. Robots, they're just like us!

The NFT itself is a video of Sophia turning a hand-painted portrait by the Italian artist Andrea Bonaceto into a digitized copy of the original artwork. Bonaceto's version featured a kaleidoscope of colors, blurring Sophia's head into an abstract swirl. Sophia then turned this into a more

straightforward artwork, with a solid blue background and simplified details around her ears and face. While Sophia and Bonaceto aren't exactly the twenty-first century's version of Andy Warhol and Edie Sedgwick, their collaboration led to a feeding frenzy on the online art market, and the piece eventually sold for nearly $700,000.

WHAT MAKES IT SPECIAL? While the rest of us fear that our jobs will be taken over by robots and artificial intelligence, Bonaceto is practically begging for it. The artist's collaboration with the world's first humanoid robot made this the first NFT created by artificial intelligence. Sophia has since gone on to create several more NFTs through her collection, Sophia's Age of Singularities. The future is here.

THE ONLINE BUZZ:

"My 1/1 artwork Sophia Instantiation also comes with a physical self-portrait painted by me! Today, 6.30 p.m. ET, we make history!"

—*Tweet by Sophia the robot, March 23, 2021*

"I think this was a big success. I am so happy that my works are so valued and appreciated."

—*Sophia the robot at a press conference after the sale, March 25, 2021*

ACKNOWLEDGMENTS

Thanks to my family for supporting me and
encouraging my love of writing. I know I'll
sell at least a few books to all of you!

Thanks to my sister, Rebecca, for roping me into this
project! Your illustrations brought this book to life. You're
my #firstfriend and favorite professional illustrator to work
with (and the only professional illustrator I've worked with).

And thanks to Nathan, for laughing at (most of) my
jokes, celebrating this process with me, and always being
there when I need to talk (because we live in the same
apartment). Soulmates/cellmates forever—I love you!

ABOUT THE AUTHOR
AND ILLUSTRATOR

Alyssa Place is a writer and journalist based in New York City. Over her ten-plus-year journalism career, she has covered breaking news, filmed a medical documentary, written extensively about personal finance, and chronicled the world of work during the COVID-19 pandemic. This is Alyssa's first book. When she's not writing professionally, Alyssa writes for fun, keeping up a pandemic blog, *Disaster Dinners*, about her cooking and baking failures (with a few successes). While she has yet to master the perfect sourdough, she loves to explore the city and eat dumplings with her husband, Nathan.

Rebecca Pry is an illustrator and designer living in Warwick, New York. She received a BFA in illustration from Rhode Island School of Design in 2013. Rebecca's art adds a humorous twist to everyday items and scenes. She has created patterns and graphics for home goods, books, accessories, and apparel and regularly shows her work in local galleries in the Hudson Valley. When she is not drawing, she is outside in a brightly colored sweater. See more at rebeccapry.com.

ABOUT CIDER MILL PRESS
BOOK PUBLISHERS

Good ideas ripen with time. From seed to harvest, Cider Mill Press
brings fine reading, information, and entertainment together between
the covers of its creatively crafted books. Our Cider Mill bears fruit
twice a year, publishing a new crop of titles each spring and fall.

"Where Good Books Are Ready for Press"

501 Nelson Place
Nashville, TN 37214

cidermillpress.com